Magnum Photos

Magnum Photos

Introduction by Fred Ritchin
Afterword by Julien Frydman

 Thames & Hudson PHOTOFILE

*The Photofile series is the original English-language
edition of the Photo Poche collection. It was conceived and
produced by the Centre National de la Photographie, Paris.
Robert Delpire is the creator and managing editor of the series,
in collaboration with Benoît Rivero, assistant director.*

Managing editor for Magnum Photos: Marie-Christine Biebuyck,
with Sabine de la Chainse and Juan Pablo Gutierrez.
www.magnumphotos.com

Thanks to Katia Duchefdelaville for her assistance

First published in the United Kingdom in 2008 by
Thames & Hudson Ltd, 181A High Holborn, London WC1V 7QX

www.thamesandhudson.com

First published in 2008 in paperback in the United States of America by
Thames & Hudson Inc., 500 Fifth Avenue, New York, New York 10110

thamesandhudsonusa.com

Photo Poche © 2007 Actes Sud, France
Photographs © Magnum Photos
Photograph by W. Eugene Smith © Aileen M. Smith,
Center for Creative Photography, Tucson
This edition © 2008 Thames & Hudson Ltd, London

British Library Cataloguing-in-Publication Data
A catalogue record for this book is available from the British Library

Library of Congress Catalog Card Number 2007905833

ISBN: 978-0-500-41094-3

Printed and bound in Italy

SEEING THE WORLD DIFFERENTLY

Two years after the apocalypse called the Second World War ended, Magnum Photos was founded. The world's most prestigious photographic agency was formed by four photographers who had been very much scarred by that conflict and were motivated both by a sense of relief that the world had somehow survived and the curiosity to see what was still there. They created Magnum to reflect their independent natures as people and photographers, the idiosyncratic mix of reporter and artist that continues to define Magnum, emphasizing not only what is seen but also the way one sees it.

Legendary photographer Henri Cartier-Bresson explained how he felt after the war in an interview with Hervé Guibert in *Le Monde*: 'I was completely lost. At the time of the liberation, the world having been disconnected, people had a new curiosity. I had a little bit of money from my family which allowed me to avoid working in a bank. I had been engaged in looking for the photo for itself, a little like one does with a poem. With Magnum was born the necessity for telling a story. Capa said to me: "Don't keep the label of a surrealist photographer. Be a photojournalist. If not, you will fall into mannerism. Keep surrealism in your little heart, my dear. Don't fidget. Get moving!" This advice enlarged my field of vision.'

Englishman George Rodger, another of Magnum's founding photographers, recalled how his colleague Robert Capa, the agency's dynamic leader, envisioned the photographer's role after World War II, which itself had been preceded by the invention of smaller, portable cameras and more light-sensitive film: 'He recognized the unique quality of miniature cameras, so quick and so quiet to use, and also the unique qualities that we ourselves had acquired during the several years of contact with all the emotional excesses that go hand in hand with war. He saw a future for us in this combination of mini cameras and maxi minds.'

There had been both emotional and physical excesses. Rodger, noted for his pictures of the Blitz and the liberation of Bergen-Belsen,

had had to walk 'three hundred miles through the bamboo forest and what seemed like a thousand mountain ranges' to escape the Japanese in Burma. He would give up war photography for ever after finding himself 'getting the dead into nice photographic compositions' upon entering the concentration camp. Cartier-Bresson spent much of the war as a German prisoner and, after escaping on his third try, in the French Resistance. Polish-born David Seymour (known as 'Chim'), who received a medal for his work in American intelligence analysing aerial photographs, had lost his parents to the Nazis (his father was a publisher of Hebrew and Yiddish books). And Hungarian Capa, whose name had been synonymous with war photography since the Spanish Civil War, made the blurred, visceral photographs of the D-Day invasion that became its symbols.

These four formed Magnum to allow them and the fine photographers who would follow the ability to work outside the formulas of magazine journalism. The agency, initially based in Paris and New York and more recently adding offices in London and Tokyo, departed from conventional practice in two fairly radical ways. It was founded as a cooperative in which the staff, including cofounders Maria Eisner and Rita Vandivert, would support rather than direct the photographers and copyright would be held by the authors of the imagery, not by the magazines that published the work. This meant that a photographer could decide to cover a famine somewhere, publish the pictures in *Life* magazine, and the agency could then sell the photographs to magazines in other countries, such as *Paris Match* and *Picture Post*, giving the photographers the means to work on projects that particularly inspired them even without an assignment.

In those days a photographer had a significant advantage: not only had television not yet become the dominant medium for imagery, but large areas of the world had hardly ever seen a photographer. They could choose to go almost anywhere they wanted, as Rodger pointed out, because in the early days one could 'take pictures of just about anything and magazines were clamouring for it; the mistake was in thinking that it would continue.' Still, four decades later, at the age of seventy-five, Rodger was averaging one sale a month of photographs he had taken in Africa in the late 1940s during the self-initiated post-war trip that he had undertaken 'to get away where the world was clean.'

The founders, and those who followed them, believed that photographers had to have a point of view in their imagery that transcended any formulaic recording of contemporary events. 'We often photograph events that are called "news",' Cartier-Bresson told Byron Dobell of *Popular Photography* magazine in 1957, 'but some tell the news step by step in detail as if making an accountant's statement. Such news and magazine photographers, unfortunately, approach an event in a most pedestrian way... There's no standard way of approaching a story. We have to evoke a situation, a truth. This is the poetry of life's reality.'

Capa, who became famous for his empathetic pictures made during the Spanish Civil War, was proficient enough in photographing both the battle itself and its powerful impact on soldiers and civilians that, in 1938, as he was turning twenty-five, *Time* magazine assigned him to a pantheon of 'perhaps half-a-dozen living photographers who are seriously and solely engaged in making the camera tell what concentrated truth they can find for it.' Cartier-Bresson, on the other hand, had a different point of view, interested in finding a visual coherence within fragmentary instants that he called 'the organic coordination of the elements seen by the eye.' His photographs often tend to emphasize the immediacy and complexity – the whole piece – of seeing itself, locating a visual geometry and often eluding a narrative.

The deaths within Magnum's first decade at war of two of the agency's founders, Capa and his colleague Chim, who along with George Rodger had been responsible for much of the agency's structure and organization, and of their gifted colleague Werner Bischof, threw the agency into turmoil. Some feel that Magnum's survival at that point was due to a desire by its remaining members not to let the deaths of their colleagues be in vain.

Swiss-born Werner Bischof and the Austrian photographer Ernst Haas were the first new Magnum members after the founders. Each had growing problems with the role of reporter. Bischof complained of his frustration with the magazines, contrasting the tragedies around him, such as the famine in India that he covered, with the short attention span of the media. 'I am powerless against the great magazines – I am an artist, and I will always be that,' Bischof wrote. Haas, after working for a short time reporting the devastation of post-war Europe, turned to colour and motion. His speciality was luminous, abstract, semi-liquid colour imagery of

otherwise banal details – shop windows, sidewalks, litter, reflections. 'I am not interested in shooting new things,' Haas wrote in 1960. 'I am interested to see things new. In this way I am a photographer with the problems of a painter, the desire is to find the limitations of a camera so I can overcome them.'

Within five years of its founding, Magnum had also added to its roster talented young photographers Eve Arnold, Burt Glinn, Erich Hartmann, Erich Lessing, Marc Riboud, Dennis Stock and Kryn Taconis. Riboud soon followed Cartier-Bresson with his own pioneering work in China, the first of many trips in what has become a lifelong interest. Arnold took a memorable series of pictures of the Black Muslims, while Taconis covered the Algerian war for independence. And soon others such as René Burri, Cornell Capa (Robert's younger brother), Elliott Erwitt and Inge Morath would join. The agency was growing. But there was a feeling that it was heading in some wrong directions.

In a memorable 1962 memo addressed to 'All photographers' Cartier-Bresson attempted to remind the photographers of their place in the world: 'I wish to remind everyone that Magnum was created to allow us, and in fact to oblige us, to bring testimony on our world and contemporaries according to our own ability and interpretations. I won't go into details here... When events of significance are taking place, when it doesn't involve a great deal of money and when one is nearby, one must stay photographically in contact with the realities taking place in front of our lenses and not hesitate to sacrifice material comfort and security.

'This return to our sources would keep our heads and our lenses above the artificial life which so often surrounds us. I am shocked to see to what extent so many of us are conditioned – almost exclusively by the desires of the clients...'

Many Magnum photographers have succeeded brilliantly in transcending 'the artificial life' and exploring life's realities subsequent to Cartier-Bresson's memo, as well as before. Bruce Davidson's *East 100th Street* is an extraordinary formal meditation on the lives of people living on an impoverished New York City block; Philip Jones Griffiths's 1971 book, *Vietnam Inc.*, is a brilliantly sardonic, even ferocious look at the policy of the United States in Vietnam; and Josef Koudelka's *Gypsies* is not only a landmark in photographic seeing for its magical portraits but a sociological document on people who have been more likely despised and feared

than valued. Like Davidson's *East 100th Street*, in-depth explorations of the lives of groups living on the fringes of their own societies would constitute a major part of Magnum's work: Martine Franck's work on the elderly, Leonard Freed on the police and criminals, Jean Gaumy on fishermen and prisoners, Paul Fusco on the homeless, Mary Ellen Mark on women in a psychiatric hospital, Eli Reed on African-Americans in America. And many others, like Griffiths, would spend long periods documenting situations far from where they lived, such as Ian Berry on apartheid, Marc Riboud on China, Chris Steele-Perkins on post-colonial Africa. Then there were others, such as Cornell Capa and David Hurn, who would complement their lives as photographers by running institutions to carry on Magnum's photojournalistic heritage: Capa's International Center of Photography in New York and Hurn's School of Documentary Photography and Film in Wales.

In the 1970s magazines increased their use of photojournalism and many Magnum members excelled, finding that they had pages and pages of photographs published. But the paradox was that as magazine editors grew both more attached to photographs and more visually sophisticated they also began to use photography in a more decorative, illustrative way. Photographers would be told specifically how to set up a cover shot, lighting and colour became the focus, and many of the more serious images did not fit the upscale ambitions of publishers.

Eventually, fewer publications would find the pages for the in-depth photo essays that were always Magnum's brightest moments. The world was becoming too complex and disturbing for the harder imagery to find a home. So while photographers still had some success in publishing photographs in magazines, such as Sebastião Salgado's 50,000 Brazilian goldminers scampering up dangerous ladders with sacks of dirt on their backs, or Jim Nachtwey's colour work on war situations throughout the world, many Magnum photographers were increasingly turning to books and exhibitions to express themselves. Susan Meiselas's *Nicaragua*, Salgado's *Sahel: L'homme en détresse* and Eugene Richards's *The Knife and Gun Club* were attempts to give a more visionary explanation of the contemporary world.

And as Magnum's photographers began to experiment with text and with book and exhibition design, their photographic language began to evolve as well. For many, the direct testimony that

Magnum's founders believed in no longer was sufficient in a media-saturated world that increasingly was using photography to illustrate the points of view of editors and art directors, of politicians and movie stars, at the expense of those of the photographers.

Raymond Depardon worked on a pioneering effort with the French daily newspaper *Libération* to report on New York City by providing a single picture every day for the newspaper's foreign-affairs page with a diary-like text that described the people he met, what he was reading, his personal feelings; Charles Harbutt's earlier *Travelog* is considered a classic and influential experiment in the interrogation of photographic seeing, of reality, of 'otherness' and intuition; Harry Gruyaert and Alex Webb's work in Morocco and the Caribbean, respectively, revelled more in the visual exoticism of the observer rather than the sociological; and Gilles Peress's *The Silence* becomes a meditation on the horrors inflicted in the civil war in Rwanda as if seen through the mind and memory of a man accused of being one of the murderers – non-fiction made into a nearly fictional account to make it more real in a world wearied by a cascade of repetitive imagery of disasters.

Many wonder, with all of Magnum's prickly personalities, with all the difficulties inherent in attempting to see differently, how the agency has managed to survive fifty years. Very few cooperatives are noted for their longevity. Magnum, in its idiosyncrasy, in its inability to stand still, has been a remarkable exception. As Henri Cartier-Bresson put it in one of his blistering memos to the other photographers: '*Vive la revolution permanente…*'

Fred Ritchin, 1997

In order to join Magnum, a photographer must first become a Nominee, then an Associate and finally a full Member. Nominees must work under the guidance of a Member for a trial period. After this period, which normally lasts two years, Nominees may apply to become Associates. This means that they may work full time for the agency, but are not Company Directors. After a further two years, they may then apply for full membership and acquire the same status and voting rights as all other Members. Occasionally a photographer passes through the Nominee and Associate stages but is refused full membership. Contributors are generally photographers who have been Members for at least twenty-five years and who keep close links with the agency but choose to no longer participate in board decisions. Correspondents are mainly photographers who have entrusted a project to Magnum but who do not work for them exclusively.

The biographies, chronology and bibliography for this book were compiled by Philippe Séclier.

ABBAS

Born 1944. Iranian. Lives in Paris. Joined Magnum in 1981. Since 1970, Abbas has covered the principal social and political events in the third world: Biafra, Bangladesh, Vietnam, South Africa, the Middle East. He photographed the Iranian revolution, from 1978 to 1980. It was not until 1997, after seventeen years of exile, that he returned to Tehran; he later published *Iran Diary 1971–2002*, a critical interpretation of his country's history that can be regarded and read as a personal journal. From 1983 to 1986 he travelled in Mexico, photographing the country as if writing a novel. From 1987 to 1994, he devoted himself to a huge overview of the international resurgence of Islam, from Xinjiang to the Maghreb. Driven by the desire to understand the internal tensions at work in Muslim societies, he produced the book *Allah O Akbar: A Journey Through Militant Islam*, exposing the contradictions between an ideology inspired by a mythical past and the universal desire for modernity and democracy. In 1995 he began a project on Christian faiths on the eve of the millennium. For five years he travelled through Christian countries and published *Faces of Christianity: A Photographic Journey* (2000), exploring this religion as a political, social and also ritual phenomenon. He then photographed animist and polytheist faiths across the world but abandoned this project on the first anniversary of the September 11 attacks, and began a project on the way that religion has replaced political ideologies as the driving force behind major international conflicts. Abbas has been a Member of Magnum since 1985.

Selected books:

Iran: La Revolution Confisquée, Paris: Clétrat, 1980; *Retornos A Oapan*, Mexico City: FCE, 1986; *Return to Mexico*, New York: W.W. Norton, 1992; *Allah O Akbar: A Journey Through Militant Islam*, London: Phaidon, 1994; *Faces of Christianity: A Photographic Journey*, New York: Harry N. Abrams, 2000; *Iran Diary 1971–2002*, Paris: Autrement, 2002; *Sur la Route des Esprits*, Paris: Delpire, 2005; *The Children of Abraham*, Paris: Intervalles, 2006

1. Armed militants outside the United States Embassy, where diplomats were held hostage on 4 November 1979, Tehran, Iran.

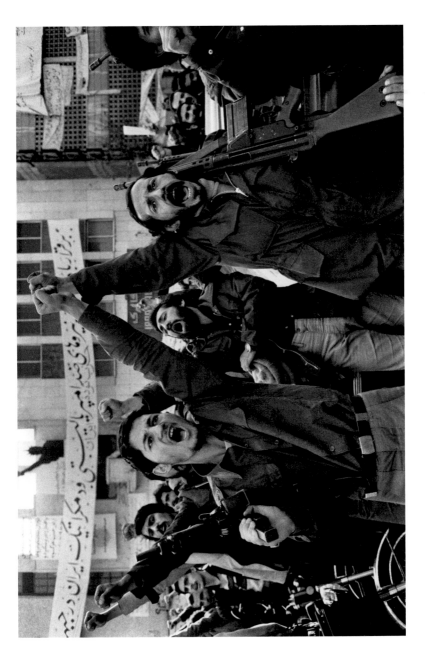

ANTOINE D'AGATA

Born 1961. French. Joined Magnum in 2004. Born in Marseilles, Antoine d'Agata left France in 1983 and spent ten years living abroad. He began taking photographs in 1990 and took courses at the ICP in New York run by Larry Clark and Nan Goldin. In 1991 and 1992 he worked as an intern at the New York offices of Magnum. He returned to France in 1993 and stopped all photography work until 1996. In 1998, his first two books were published: *De Mala Muerte* and *Mala Noche*, which captured his own personal view of the night and of being a wanderer. Represented by the Vu agency from 1999, he won the Niépce Prize in 2001. In 2003 he published two books, *Vortex* and *Insomnia*, and joined Magnum as a Nominee the following year. Since then he has lived, worked and exhibited in several countries. His work, based on danger, desire and the unconscious, has been selected for many museums and private collections. He became a Magnum Associate in 2006.

Selected books:
De Mala Muerte, Cherbourg: Le Point du Jour Éditeur, 1998; *Mala Noche*, Nantes: En Vues, 1998; *Hometown*, Cherbourg: Le Point du Jour Éditeur, 2001; *Vortex*, Anglet: Atlantica, 2003; *Insomnia*, Marseilles: Images en Manoeuvres, 2003; *Stigma*, Marseilles: Images en Manoeuvres, 2004; *Psychogéographie*, Cherbourg: Le Point du Jour Éditeur, 2005; *Manifeste*, Cherbourg: Le Point du Jour Éditeur, 2005

2. Hamburg, Germany, 2000.

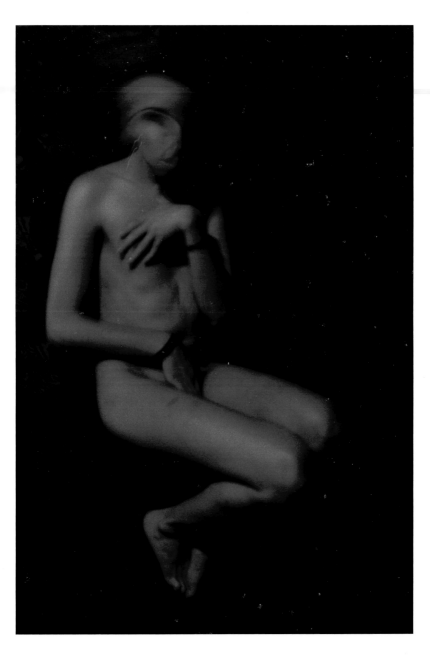

EVE ARNOLD

Born 1912. American. Lives in London. Joined Magnum
in 1951. Born to a family of Russian immigrants living in
Philadelphia, Eve Arnold began taking photographs in 1946,
while she was working in a photo-finishing lab. In 1948, she
studied photography with Alexey Brodovitch at the New
School for Social Research in New York. Her teacher was
impressed by her images of Harlem. In 1957 she became a
Member of Magnum. She has photographed many celebrities
from the worlds of politics, cinema and the arts, including
Malcolm X, Mikhail Baryshnikov and, perhaps most famously,
Marilyn Monroe, who became the subject of two of Arnold's
books. Based in the UK since 1962, she has travelled all over
the world. Her reportage work in Asia brought her
international acclaim, particularly for her book *In China*
in 1980. She is also deeply involved in women's issues and
published *The Unretouched Woman* in 1976. In 1980 she
received a Lifetime Achievement Award from the American
Society of Magazine Photographers, and in 1995 she was
elected a Master Photographer by the International Center of
Photography, New York. In the same year she was also made
a Fellow of the Royal Photographic Society and published the
book *In Retrospect*.

Selected books:

The Unretouched Woman, New York: Alfred A. Knopf, 1976; *Flashback!
The 50s*, New York: Alfred A. Knopf, 1978; *In China*, New York: Alfred A.
Knopf, 1980; *In America*, New York: Alfred A. Knopf, 1983; *Marilyn
Monroe: An Appreciation*, New York: Alfred A. Knopf, 1987; *Private View:
Inside Baryshnikov's American Ballet Theatre*, New York: Bantam Books,
1988; *All in a Day's Work*, New York: Bantam Books, 1989; *The Great
British*, New York: Alfred A. Knopf, 1991; *In Retrospect*, New York: Alfred
A. Knopf, 1995; *Ciné-Roman*, Paris: Cahiers du Cinéma, 2001; *Handbook
(with Footnotes)*, New York and London: Bloomsbury, 2004; *Marilyn
Monroe by Eve Arnold*, New York: Harry N. Abrams, 2005

3. Museum of Modern Art, New York City, USA, 1959.

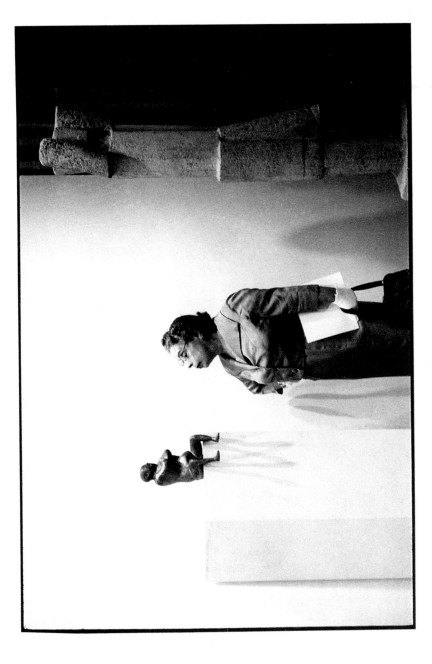

MICHA BAR-AM

Born 1930. Israeli. Lives in Ramat Gan. Joined Magnum in 1968. Born in Berlin, Micha Bar-Am emigrated to Palestine with his family in 1936 and grew up in Haifa. He worked in the port there and was drafted into the army at the outbreak of the Arab-Israeli conflict in 1948. In 1949 he was a founder member of the Kibbutz Malkiya in Galilee and later became a member of the Kibbutz Gesher HaZiv. In the early 1950s he began to use borrowed cameras to photograph kibbutz life, and took part in expeditions into the Sinai Desert in search of the Dead Sea Scrolls. After the Sinai campaign in 1956 he published his first book, *Across Sinai*, and joined the staff of *Bamachane* (an army newspaper) as a photojournalist. In 1961, he covered the Eichmann trial. In 1966 he went freelance and met Cornell Capa, with whom he worked during the Six-Day War in 1967. The following year he became a Correspondent for Magnum in the Middle East and began to work regularly for the *New York Times*. His images of the Yom Kippur War in 1973 increased his international reputation. In 1974, together with Cornell Capa, he became a founder of the International Center of Photography in New York and began to curate exhibitions there. In 1977, he founded the Department of Photography at Tel Aviv Museum, which he ran until 1993. Micha Bar-Am won the Robert Capa Gold Medal in 1959 and 1960, and the Israel Prize for Visual Arts in 2000.

Selected books:

Across Sinai, Tel Aviv: Hakibbutz Hameuchad, 1957; *Portrait of Israel*, New York: American Heritage, 1970; *The Jordan*, Jerusalem: Massada, 1981; *Jewish Sites in Lebanon*, Jerusalem: Ariel Publishing House, 1984; *On The Edge*, Tel-Hai: Tel-Hai Museum, 1992; *The Last War*, Tel Aviv: Keter, 1996; *Israel: A Photobiography*, New York: Simon & Schuster, 1998

4. Israeli soldiers and Egyptian prisoners of war, under an Egyptian artillery barrage of shells on the 'Hatzer', a bridgehead where the Israeli forces were deploying to cross to the west side of the Suez Canal, 1973.

BRUNO BARBEY

Born 1941. French. Lives in Paris. Joined Magnum in 1964. Bruno Barbey grew up in Morocco and then studied at the École des Arts et Métiers in Vevey, Switzerland, from 1960 to 1962. In the early 1960s he produced a black-and-white photo essay on the Italians, and worked in Africa and Europe for the Lausanne publishing house Éditions Rencontre. He also worked for *Vogue* during this period. His work on civil conflicts includes Biafra, Vietnam, the Middle East, Northern Ireland, Kurdistan and Cambodia. In 1968 he became a Member of Magnum and recorded the student uprising in Paris. Between 1979 and 1981, he made several trips to Poland during a critical time in the country's history when the Solidarity movement was gaining in strength. He was also present during the fall of the Berlin Wall in 1989 and covered the Gulf War in 1991. At the same time, he was also engaged on a thirty-year project on Morocco. His many honours include the Overseas Press Club Award, the University of Missouri Photojournalism Award, and the French National Order of Merit in 1985. His photographs have been exhibited all over the world and feature in many museum collections.

Selected books:

Ceylan, Paris: Barret, 1974; *Iran*, Paris: Jeune Afrique, 1976; *Nigeria*, Paris: Jeune Afrique, 1978; *Bombay*, Amsterdam: Time-Life Books, 1979; *Portrait of Poland*, London: Thames & Hudson, 1982; *Le Gabon*, Paris: Le Chêne, 1984; *Portugal*, Hamburg: Hoffmann & Campe, 1988; *Fès, immobile, immortelle*, Paris: Imprimerie Nationale, 1996; *Gens des nuages*, Paris: Stock, 1997; *Mai 68*, Paris: La Différence, 1998; *Bruno Barbey: Photo Poche*, Paris: Nathan, 1999; *Essaouira*, Paris: Le Chêne, 2000; *The Italians*, New York: Harry N. Abrams, 2002; *My Morocco*, London: Thames & Hudson, 2003

5. Essaouira, Morocco, 1985.

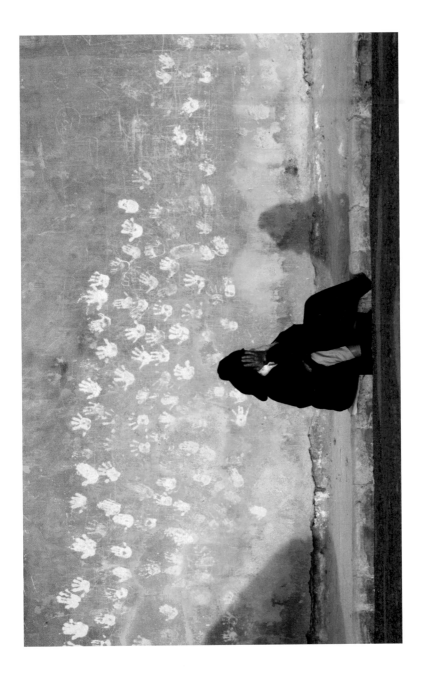

JONAS BENDIKSEN

Born 1977. Norwegian. Lives in New York. Joined Magnum in 2004. Jonas Bendiksen's career began when he became an intern at the London offices of Magnum at the age of nineteen. After his internship, he set off for Russia as a freelance photographer. He spent several years photographing the countries of the former Soviet Union, interested in the people and communities that form isolated enclaves within the rest of Europe. This long-term project won him a World Press Photo award in 2005. A year later, he published this work under the title *Satellites*. Bendiksen's many awards include the 2003 Infinity Award from the International Center of Photography, New York, and first prize in the Pictures of the Year International Awards. A grant from the Alicia Patterson Foundation has allowed him to spend several years on a project documenting life in the world's largest slums and shanty towns. His work has been exhibited in London, Amsterdam and New York, and has appeared in magazines including *GEO*, *National Geographic*, *Newsweek*, *Vanity Fair*, *The Sunday Times Magazine* and *Mother Jones*.

Selected books:
Satellites, New York: Aperture, 2006

6. The Shilpiri household in Dharavi, one of Mumbai's oldest slums. India, 2006.

IAN BERRY

Born 1934. British. Lives in Buckinghamshire. Joined Magnum in 1962. Ian Berry left Britain in 1952 and went to work in South Africa as a photographer for the *Rand Daily Mail* and *Drum* magazine until 1959–60. On 21 March 1960 he was present at a peaceful demonstration in the township of Sharpeville which turned into a massacre. His photographs were the only ones to record the event and were used in the subsequent trial to prove the innocence of the victims. When he returned to Europe in 1962, Henri Cartier-Bresson invited him to join Magnum. He moved to London in 1966, became a Magnum Member in 1967, and worked for *The Observer Magazine* (1966–70). He has photographed conflicts in various parts of the world (the Middle East, Northern Ireland, Zaire, Vietnam) and recorded social and political change in China and the former Soviet Union. In 1974 he was awarded the first major photographic bursary from the British Arts Council, which led him to explore his homeland in work that was published in the book *The English* in 1978. He also continued to work in South Africa, documenting apartheid in all its forms, up to and beyond the election of Nelson Mandela in 1994. These images were published in the major book *Living Apart* in 1996.

Selected books:

The English, Harmondsworth: Penguin, 1978; *Black and Whites: L'Afrique du Sud*, Paris: Camera International, 1988; *Living Apart: South Africa Under Apartheid*, London: Phaidon, 1996

7. Tibetan novice monks on their way to prayer, Gansu Province, China, 1996.

WERNER BISCHOF

1916–54. Swiss. Joined Magnum in 1949. After studying
photography and graphic art at the Kunstgewerbeschule,
Zurich (1932–36), Werner Bischof opened a studio in Zurich
and worked for an ad agency. In 1942 he began to work for
the Swiss magazine *Du*. After 1945, he travelled across
Europe, documenting communities in the regions devastated
by the war. In 1949, he became one of the first Members of
Magnum, and worked for *Picture Post*, *Life* and *Epoca*. In 1951
he travelled to the Far East, first spending six months in India;
his work on the Bihar famine was published in *Life* and won
him worldwide acclaim. He went on to work in South Korea,
Japan and Hong Kong, as well as Indochina as a reporter for
Paris Match. He returned to Europe in 1953 and then set off
again for South America. In 1954 he travelled from New York
to Mexico by car with his wife Rosellina, then continued his
journey down into Latin America. He died in a road accident
in the Peruvian Andes on 16 May 1954. One year later, he was
posthumously awarded the first Prix Nadar for his book *Japan*.
Since then, his body of work has been celebrated through
exhibitions all over the world.

Selected books:

Werner Bischof: 24 Photos, Berne: L.M. Kohler, 1946; *Le Haras fédéral
d'Avenches*, Zurich: Baumann, Conzett & Huber, 1954; *Japan*, New York:
Simon & Schuster, 1954; *From Incas to Indios*, New York: Universe, 1956;
Carnet de Route, Zurich: Delpire, 1957; *Querschnitt*, Zurich: Arche, 1961;
Werner Bischof 1916–1954, New York: ICP/Grossman, 1966 and 1974;
Photos and Drawings, New York: Amphoto, 1976; *Werner Bischof:
Photofile*, London: Thames & Hudson, 1989; *Werner Bischof 1916–1954:
His Life and Work*, Boston: Bulfinch Press; London: Thames & Hudson,
1990; *After the War Was Over*, Washington DC: Smithsonian Institution
Press; London: Thames & Hudson, 1997; *Questions To My Father*,
London: Trolley, 2004; *Werner Bischof Pictures*, Göttingen: Steidl, 2006

8. New York City, USA, 1953.

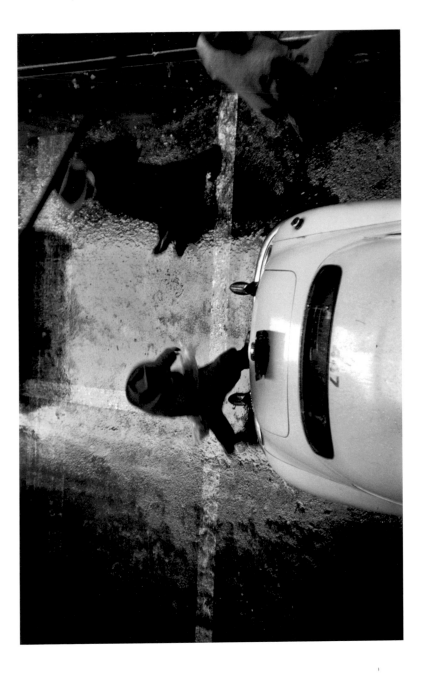

RENÉ BURRI

Born 1933. Swiss. Lives in Zurich and Paris. Joined Magnum
in 1955. Between 1949 and 1953, René Burri studied at the
École des Arts Appliqués in his home town of Zurich. After
1953, he worked as a documentary filmmaker and began to
take photographs with a Leica during his military service. In
1955 he became a Magnum Associate and was acclaimed for
his report on deaf-mute children which was published in *Life*.
From 1956, he travelled throughout Europe and the Middle
East, and also in Latin America, where he photographed the
Gauchos in a series that was published in *Du* in 1959. For the
same Swiss magazine, he also photographed artists including
Picasso, Giacometti and Le Corbusier. In 1959 he became
a Magnum Member and began work on his book *Die
Deutschen*, which was first published in Switzerland in 1962,
then the following year by Robert Delpire under the title *Les
Allemands*. In 1963 he went to Cuba and photographed Che
Guevara during a press interview; these iconic images of the
revolutionary and his cigar travelled the world. He became
a founder of Magnum Films in 1965 and spent six months in
China making a film for the BBC, called *The Two Faces of
China*. In 1982 he opened the Magnum Gallery in Paris, and
continued his photographic work, as well as sketching and
making collages. In 1998 René Burri won the Dr Erich Salomon
Prize from the German Association of Photography. In 2004–5,
a major retrospective of his photographic work was held at
the Maison Européenne de la Photographie in Paris and in
several other European museums.

Selected books:

Die Deutschen, Zurich: Fretz & Wasmuth, 1962; *Les Allemands*, Paris:
Delpire, 1963; *The Gaucho*, New York: Crown Publishers, 1968; *One
World*, Sulgen, Switzerland: Benteli Verlag, 1984; *Ein Amerikanischer
Traum; Fotografien aus der Welt der NASA und des Pentagon*,
Nordlingen: Greno-Delphi, 1986; *Che Guevara: Photo Poche*, Paris:
Nathan, 1997; *Cuba y Cuba*, Milan: Motta; Washington DC: Smithsonian
Books, 1998; *René Burri: Photo Poche*, Paris: Nathan, 1998; *77 Strange
Sensations*, Zurich: Dino Simonett, 1998; *Le Corbusier*, Basel: Birkhaüser;
Princeton, NJ: Princeton Architectural Press, 1999; *Luis Barragán*,
London: Phaidon, 2000; *René Burri Photographs*, London: Phaidon,
2004; *Pour Le Corbusier*, Baden: Lars Müller, 2006

9. Rio de Janeiro, Brazil, 1960.

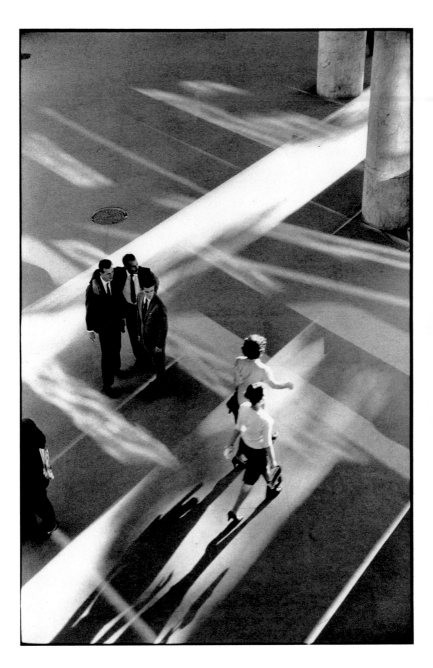

CORNELL CAPA

Born 1918. Hungarian, naturalized American. Lives in New York. Joined Magnum in 1954. He began printing photographs by his brother Robert in Paris in 1936. He left for New York the following year and worked for the Pix agency. From 1938 to 1941, he worked in the photo lab of *Life* magazine, then served in the US Air Force's Photo Intelligence Unit. A staff photographer for *Life* from 1946 to 1954, he joined Magnum after his brother's death and became President in 1956, after the death of David 'Chim' Seymour. In the late 1950s, he founded the Bischof-Capa Memorial Fund, a precursor of the International Center of Photography in New York which he went on to found in 1974. In 1961 he followed John F. Kennedy to the White House and covered his first 100 days in office for Magnum. In 1967, he curated the exhibition *The Concerned Photographer* in New York, bringing together work by Robert Capa, Werner Bischof, David Seymour, André Kertész and Dan Weiner. He stopped taking photographs in 1974 in order to devote himself to running the ICP, and in 1994 he was named Founding Director Emeritus.

Selected books:
Retarded Children Can Be Helped, Great Neck, NY: Channel Press, 1957; *The Savage My Kinsman*, New York: Harper Bros., 1961; *Farewell to Eden*, New York: Harper & Row, 1964; *Adlai Stevenson's Public Years*, New York: Grossman, 1966; *Israel, the Reality*, New York: The Jewish Museum; London: Thames & Hudson, 1969; *Jerusalem, City of Mankind*, New York: Grossman, 1974; *Margin of Life*, New York: Grossman, 1974; *Master Photographs*, New York: W.W. Norton, 1990; *Capa & Capa: Brothers in Photography*, New York: ICP, 1991; *Cornell Capa: Photographs*, Boston: Bulfinch Press, 1992; *JFK For President*, New York: ICP; Göttingen: Steidl, 2004

10. A Hebrew lesson. New York City, USA, 1955.

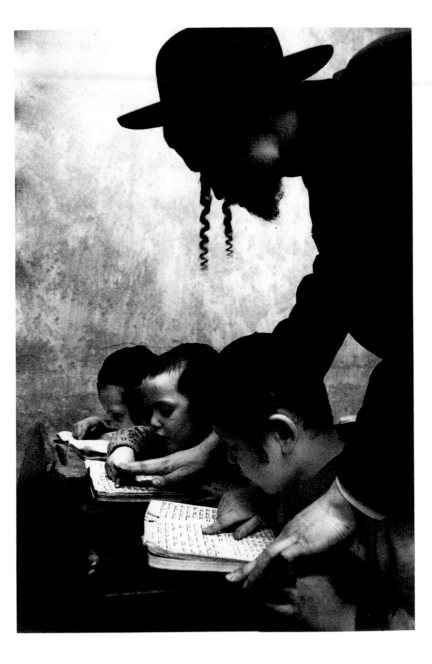

ROBERT CAPA

1913–54. Hungarian, naturalized American. Founder member
of Magnum, 1947. He was known as Andre Erno Friedmann
when he left Hungary in 1931 to study political science in
Berlin. It was there that he began taking photographs,
working for the Dephot agency. Forced into exile by the rise
of the Nazis, he moved to Paris in 1933, where he took part in
the early days of the Alliance Photo agency and met the
German-born photojournalist Gerda Taro, who became his
partner. Together they invented the 'famous' Robert Capa and
sold his photographs under that name. From 1936 to 1938 he
documented the Spanish Civil War. After the death of Gerda
Taro in Spain, Capa travelled to China and then emigrated
to the USA in 1939. He photographed the Second World War,
notably the US landings at Omaha Beach on D-Day, as well as
the liberation of Paris, as a correspondent for *Life* and *Collier*.
In 1947 he founded Magnum Photos with Henri Cartier-Bresson,
David 'Chim' Seymour and George Rodger. In the same year,
he travelled to Russia with John Steinbeck and to Israel with
Irwin Shaw, where he witnessed the creation of the Hebrew
state. On 25 May 1954 he died in Indochina after stepping on
a landmine. In 1955, the Robert Capa Gold Medal Award was
created to honour exceptional photographers.

Selected books:

Death in the Making (with Gerda Taro), New York: Covici Friede, 1938;
Invasion!, New York: Appleton Century Co., 1944; *Slightly Out of Focus*,
New York: Henry Holt & Co., 1947; *A Russian Journal* (with John
Steinbeck), New York: Viking Press, 1948; *Report on Israel*, New York:
Simon & Schuster, 1950; *Images of War*, New York: Grossman, 1964;
Robert Capa 1913–1954, New York: Grossman, 1974; *Robert Capa:
A Biography* (by Richard Whelan), New York: Alfred A. Knopf, 1985;
Robert Capa: Photographs, New York: Alfred A. Knopf, 1985; *Children
of War, Children of Peace*, Boston: Bulfinch Press, 1991; *Robert Capa:
Photo Poche*, Paris: CNP, 1993; *Heart of Spain*, New York: Aperture, 1999;
Robert Capa: The Definitive Collection, London: Phaidon, 2001; *Juste
un peu flou*, Paris: Delpire, 2003; *Capa connu et inconnu*, Paris: BNF
Éditions, 2004; *This Is War!: Robert Capa at Work*, Göttingen: Steidl;
New York: ICP, 2007

11. Liberation of Chartres, France, 1944.

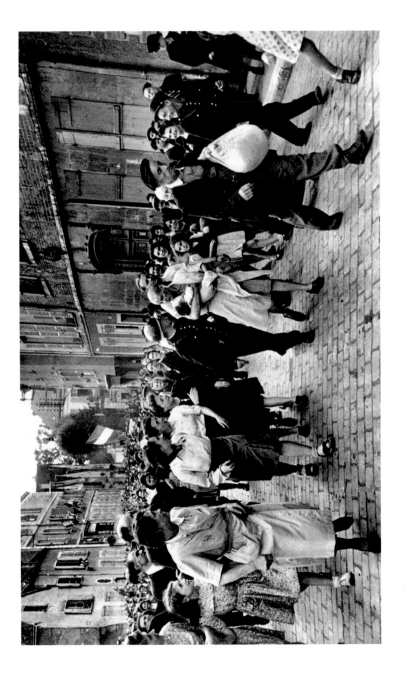

HENRI CARTIER-BRESSON

1908–2004. French. Founder member of Magnum, 1947. Secondary education at the Lycée Condorcet. He studied painting with André Lhote (1927–28) and got to know Surrealists such as André Breton and Max Ernst. After spending a year in Côte d'Ivoire, he went to Eastern Europe with André Pieyre de Mandiargues. His first exhibition was held in 1933 at the Julien Levy Gallery in New York. He travelled to Mexico, where he spent a year, then returned to Paris and became assistant to Jean Renoir. In 1940 he was taken prisoner but escaped in February 1943 after two unsuccessful attempts. In 1946 he returned to New York where he selected photographs for a 'posthumous' exhibition of his work at MoMA. He travelled to India, China and Indonesia. *Images à la sauvette* was published by Tériade in 1952, and in the US under the title *The Decisive Moment*. In 1954 he became one of the few Western photographers allowed into the Soviet Union; in the same year he published *Les Danses à Bali* and *D'une Chine à l'autre*. This was the start of a long collaboration with Robert Delpire. He became a Magnum Contributor in 1966 and from the 1970s on, devoted himself primarily to drawing and painting. In 2003 there was a major retrospective of his work at the Bibliothèque Nationale de France and the Fondation Henri Cartier-Bresson was opened in Montparnasse, Paris. One year later, Henri Cartier-Bresson died, shortly before his 96th birthday.

Selected books:

Images à la sauvette/The Decisive Moment, Paris: Verve; New York: Simon & Schuster, 1952; *Les danses à Bali*, Paris: Delpire, 1954; *D'une Chine à l'autre*, Paris: Delpire, 1954; *The Europeans*, New York: Simon & Schuster, 1955; *About Russia*, London: Thames & Hudson; New York: Viking Press, 1974; *Henri Cartier-Bresson: Photographer*, Boston: Bulfinch Press; London: Thames & Hudson, 1979; *Photoportraits*, London: Thames & Hudson, 1985; *The Early Work*, New York: Museum of Modern Art, 1987; *America in Passing*, Boston: Bulfinch Press; London: Thames & Hudson, 1991; *Mexican Notebooks 1934–1964*, London: Thames & Hudson, 1995; *Tête à Tête*, Boston: Bulfinch Press; London: Thames & Hudson, 1998; *The Mind's Eye*, New York: Aperture, 1999; *Des images et des mots*, Paris: Delpire, 2003; *The Man, The Image & The World: A Retrospective*, London: Thames & Hudson, 2003; *Henri Cartier-Bresson: A Biography* (by Pierre Assouline), London: Thames & Hudson, 2005; *An Inner Silence: The Portraits of Henri Cartier-Bresson*, London: Thames & Hudson, 2006; *Scrapbook*, London: Thames & Hudson, 2006; *Henri Cartier-Bresson: Photofile*, London: Thames & Hudson, 2007

12. Brussels, 1932.

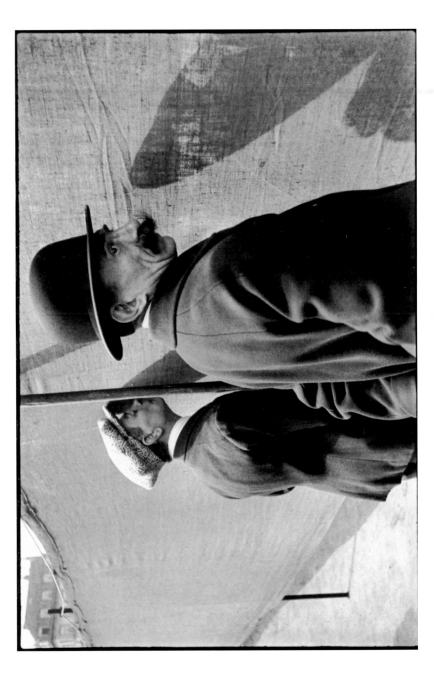

CHIEN-CHI CHANG

Born 1961. Taiwanese. Lives in New York and Taipei. Joined
Magnum in 1995. After studying English literature at Soochow
University in Taiwan, Chien-Chi Chang became interested
in photography while at Indiana University in the US. He got
an internship at *National Geographic* and in the early 1990s
worked for the *Seattle Times* and the *Baltimore Sun*. He began to
focus on the lives of a group of illegal immigrants in Chinatown
in New York and followed them for several years. This series
was published in *National Geographic*, *Time* and *GEO*, and
won him a World Press Photo award in 1998. His work on
arranged marriages between Taiwanese men and Vietnamese
women, and on the Lung Fa Tang mental institution in Taiwan
are proof of his interest in the human condition and in different
aspects of freedom and the relationships that connect or
alienate people. Chien-Chi Chang has won several awards
including being named Magazine Photographer of the Year
by the US Press Photographers' Association in 1998, and
winning the W. Eugene Smith Memorial Fund for Humanistic
Photography in 1999. He has been a Magnum Member since
2001.

Selected books:
I do I do I do, Taiwan: Premier Foundation, 2001; *The Chain*, London:
Trolley, 2002; *Double Happiness*, New York: Aperture, 2005

13. The photographer's niece, on a new suspension bridge. Wuri, Taiwan, 2003.

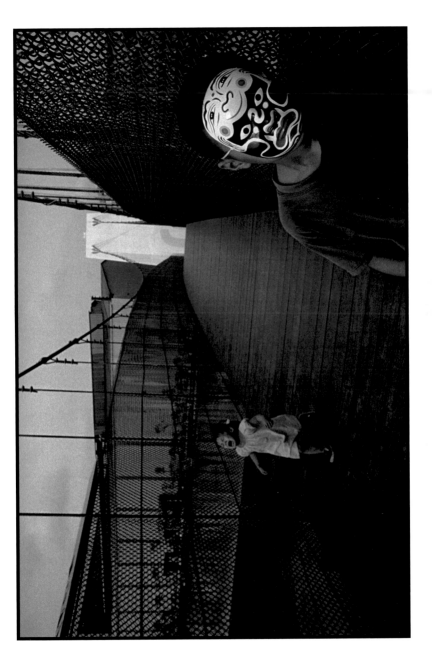

BRUCE DAVIDSON

Born 1933. American. Lives in New York. Joined Magnum in 1958. Bruce Davidson began taking photographs at the age of ten in Oak Park, Illinois, and won first prize in the Kodak National High School Competition at the age of sixteen. He studied photography at Rochester Institute of Technology (1951–54), then attended Yale. After becoming freelance photographer for *Life* in 1957, he joined Magnum as an Associate the following year (and became a Member in 1959). From 1961, he documented the civil rights movement, a project for which he received a Guggenheim Fellowship in 1962. He famously followed the Selma to Montgomery marches in 1965, as well as photographing Martin Luther King on several occasions. In 1966 he was awarded the first grant for photography from the National Endowment for the Arts. He then became fascinated with a block in Spanish Harlem, New York; this series, *East 100th Street*, first appeared in *Du* magazine in 1969, before being published the following year by Harvard University Press and exhibited at MoMA. After projects on the New York subway (1980) and Central Park (1991–95), Bruce Davidson published *Brooklyn Gang* in 1998, featuring images taken in 1959. Since then, there have been further books, including the remarkable *Time of Change*, on the racial segregation of the 1960s, which Bruce Davidson captured in a series of striking images.

Selected books:

The Bridge, New York: Harper & Row, 1964; *The Negro American*, Boston: Houghton Mifflin, 1966; *East 100th Street*, Cambridge, MA: Harvard University Press, 1970; *Subsistence USA*, New York: Holt, Rinehart & Winston, 1973; *Bruce Davidson Photographs*, New York: Simon & Schuster, 1978; *Bruce Davidson: Photo Poche*, Paris: CNP, 1984; *Subway*, New York: Aperture, 1986; *Central Park*, New York: Aperture, 1995; *Brooklyn Gang*, Santa Fe, NM: Twin Palms, 1998; *Portraits*, New York: Aperture, 1999; *Time of Change: Civil Rights Photographs 1961–1965*, West Hollywood, CA: St Ann's Press, 2002; *England/Scotland 1960*, Göttingen: Steidl, 2003; *East 100th Street*, West Hollywood, CA: St Ann's Press, 2005; *Circus*, Göttingen: Steidl, 2007

14. Clyde Betty Circus, Palisades, New Jersey, 1958.

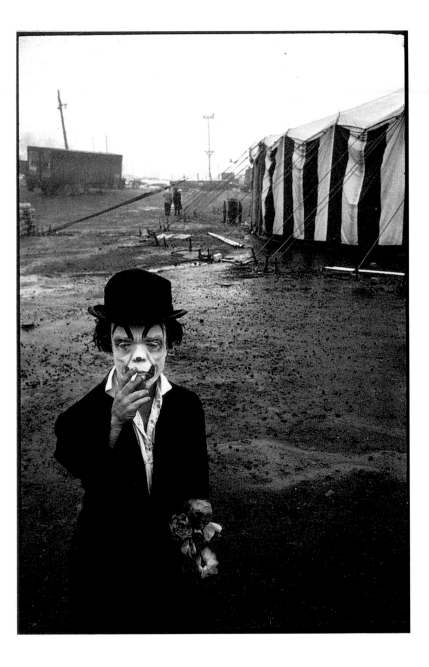

RAYMOND DEPARDON

Born 1942. French. Lives in Paris. Joined Magnum in 1978. The youngest child of a farming family, he began to photograph the family farm in Garet at the age of twelve. In 1958 he went to Paris and joined the Dalmas agency as a reporter in 1960. In 1966 he co-founded the Gamma agency and continued to report from many international locations. From 1974 to 1977, he photographed and filmed the kidnapping of the ethnologist Françoise Claustre in northern Chad. He also began to make documentary films: *1974, une partie de campagne* and *San Clemente*. After joining Magnum he continued with reportage work and books. His 1981 film *Reporters* was a success. In 1984, he took part in the DATAR project, photographing the French countryside, and continued to make films (*Fait divers*, *Urgences*, *La Captive du désert*). In 1991 he received the French National Photography Prize. In 1995, he won the César award for Best Documentary Film, for *Délits flagrants*. In 1998, he began a series of three films on rural life in France: *Profils paysans: l'approche* (2001), *Profils paysans: le quotidien* (2005), *La Vie moderne* (2008). In 2000, the Maison Européenne de la Photographie in Paris held a major exhibition of his work. His series of films on the French judicial system (*10e chambre*, *Instants d'audiences*) were shown in Cannes in 2004. For the Fondation Cartier, he created a film installation on twelve major cities which was shown in Paris, Berlin and Tokyo between 2004 and 2007. In 2006, he was guest artistic director for the Rencontres d'Arles photography festival. He has directed 18 full-length films and published 47 books.

Selected books:
Notes, Paris: Arfuyen, 1979; *Correspondance new-yorkaise*, Paris: Éd. de l'Étoile/Libération, 1981; *Le Désert américain*, Paris: Éd. de l'Étoile, 1983; *San Clemente*, Paris: CNP, 1984; *Depardon Cinéma*, Paris: Cahiers du Cinéma, 1993; *La Ferme du Garet*, Arles: Carré/Actes Sud, 1995; *En Afrique*, Paris: Le Seuil, 1996; *Voyages*, Paris: Hazan, 1998; *Errance*, Paris: Le Seuil, 2000; *Détours*, Paris: Paris Audiovisuel, 2000; *The Desert*, London: Thames & Hudson, 2000; *Paris-Journal*, Paris: Hazan, 2004; *7X3*, Arles: Actes Sud; Paris: Fondation Cartier, 2004; *PPP*, Paris: Le Seuil, 2006; *Our Farm*, Arles: Actes Sud, 2006; *Villes/Cities/Städte*, Göttingen: Steidl, 2007

15. Shanghai, China, 2004.

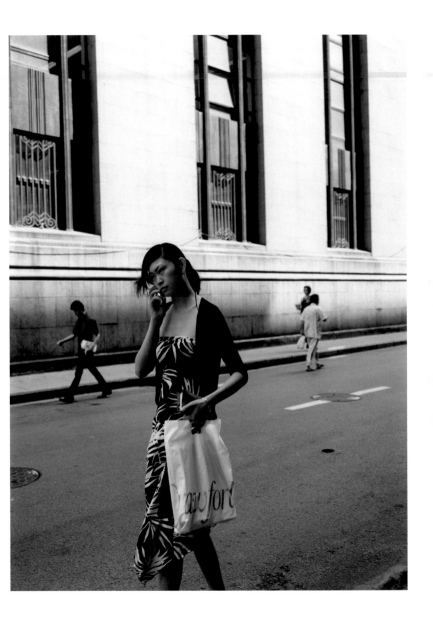

THOMAS DWORZAK

Born 1972. German. Lives in New York. Joined Magnum in 2000. After attending high school in Germany, Thomas Dworzak began to travel around Eastern Europe, spending time living in Prague and Moscow, where he learned Russian. In 1991 he became a freelance photographer and covered the conflict in the former Yugoslavia. In 1993 he moved to Tblisi in Georgia and photographed the Caucasus region. He covered the war in Chechnya (1994–96) and the conflict in Kosovo (1999), but it was his work on the fall of Grozny in February 2000 that brought him international recognition. His exclusive photographs were published by *Paris Match*. Following September 11, 2001, he spent several months in Afghanistan for *The New Yorker*. Since then he has worked for many major US magazines and has travelled to Iraq, Iran, Haiti, Ukraine and anywhere else that events demand. He has already won several major prizes, including a World Press Photo award in 2001. He has been a Magnum Member since 2004.

Selected books:
Taliban, London: Trolley, 2003; *M*A*S*H I*R*A*Q*, London: Trolley, 2007

16. Graduation ceremony in the Novotsherkassk Cossack cadet corps. Novotsherkassk, Stavropol Region, Russia, 1997.

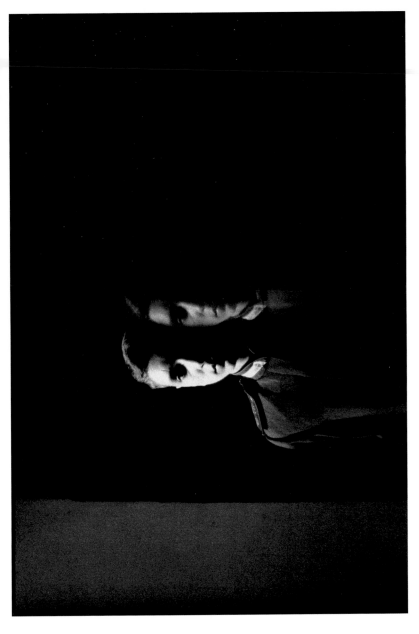

NIKOS ECONOMOPOULOS

Born 1953. Greek. Lives in Athens. Joined Magnum in 1990.
After studying law in Italy and working as a freelance
journalist in Greece, Nikos Economopoulos became a full-
time photographer in 1988. From 1990 to 1994, he worked on
a project on the Balkans, which won him the Mother Jones
Award for Documentary Photography in 1992 and was
turned into the book *In The Balkans* in 1995. A Magnum
Member since 1994, he is also deeply interested in minority
communities in Greece, including Muslims and gypsies.
In 1999 and 2000 he documented the exodus of Albanian
refugees fleeing from Kosovo. Nikos Economopoulos has also
made regular trips to Turkey, a country he has photographed
over two decades and which earned him the 2001 Ipektsi
Award for promoting peace and friendship between the
people of Greece and Turkey.

Selected books:
In The Balkans, New York: Harry N. Abrams, 1995; *Lignite Miners*,
Athens: Indiktos, 1998; *Dance ex machina*, Athens: Difono, 2000; *About
Children*, Athens: Metaixmio, 2001; *Economopoulos, Photographer*,
Athens: Metaixmio, 2002

17. Folk dance during the feast of St John, Avlona village,
Karpathos, Greece, 28 August 1989.

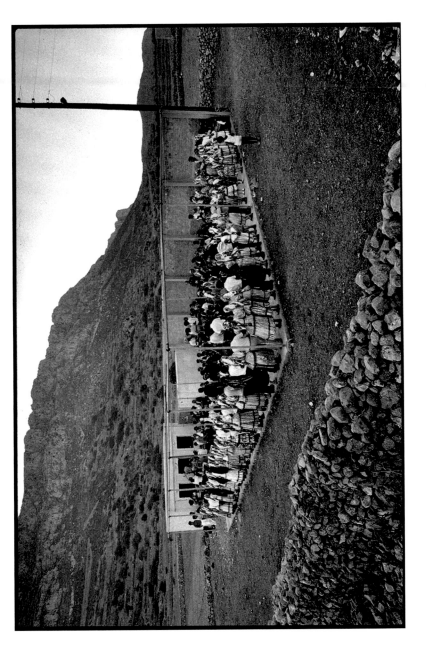

ELLIOTT ERWITT

Born 1928. American. Lives in New York. Joined Magnum in 1953. Born in Paris to Russian parents, brought up in Milan and then Paris, Elliott Erwitt emigrated to the US with his family in 1939. While studying at Los Angeles city college, he worked in a photo lab. In 1948 he moved to New York, where he studied film at the New School of Social Research. A US Army photographer from 1951 to 1953, he also did freelance work for *Collier*, *Look*, *Life* and *Holiday*. He joined Magnum in 1953. Elliott Erwitt's international reputation was made by two photographs taken in Moscow: the first was an image of Soviet missiles on parade in Red Square in 1957, and the second was a candid shot of Nikita Khrushchev and Richard Nixon arguing at an industrial exhibition in 1959. Erwitt continued to travel the world and worked for magazines and in the field of corporate advertising. Since 1970, he has also made documentary films. His photographs of dogs in unusual situations display his talents as a humorist. Elliott Erwitt has twice been President of Magnum.

Selected books:

Photographs and Anti-Photographs, Greenwich, CT: New York Graphic Society; London: Thames & Hudson, 1972; *Observations on American Architecture*, New York: Viking Press, 1972; *Son of Bitch*, New York: Grossman, 1974; *Recent Developments*, New York: Simon & Schuster, 1978; *Personal Exposures*, New York and London: W.W. Norton, 1988; *On The Beach*, New York and London: W.W. Norton, 1991; *To the Dogs*, New York: DAP/Scalo, 1992; *Between the Sexes*, New York and London: W.W. Norton, 1994; *Dog Dogs*, London: Phaidon, 1998; *Museum Watching*, London: Phaidon, 1999; *Snaps*, London: Phaidon, 2001; *Elliott Erwitt's Handbook*, New York: Quantuck Lane Press, 2003; *Elliott Erwitt: Photofile*, London: Thames & Hudson, 2007; *Unseen*, New York: te Neues, 2007

18. Palace of Versailles, France, 1975.

MARTINE FRANCK

Belgian. Lives in Paris. Joined Magnum in 1980. Born in
Antwerp, Martine Franck spent her childhood in the US
and Great Britain. She studied art history at the University
of Madrid and the École du Louvre in Paris. She met Ariane
Mnouchkine and travelled with her to the Far East. On
returning to France, she worked as an assistant to Eliot
Elisofon and to Gjon Mili at *Life*. She joined the Vu agency
in 1970 and was a founder member of the Viva agency two
years later. She produced portraits of artists and writers and
reportages on humanitarian topics. She also photographed
all productions by the Théâtre du Soleil, from its founding in
1964. From 1985, she has collaborated with the Little Brothers
of the Poor, a charity organization. In 1998 she produced a
book on the Gaelic-speaking community of Tory Island, off the
coast of Ireland, which she first visited in 1993; in 2000, a book
on Tibetan Buddhist children and in 2004, a book on the
Comédie-Française production of La Fontaine's *Fables*.
Together with Henri Cartier-Bresson and their daughter,
Mélanie, she founded the Fondation Cartier-Bresson in Paris
in 2003. She continues to photograph artists in their studios.

Selected books:
Étienne Martin, sculpteur, Brussels: La Connaissance, 1970; *La Sculpture
de Cardenas*, Brussels: La Connaissance, 1971; *Martine Franck*, Paris:
Contrejour, 1976; *Les Lubérons*, Paris: le Chêne, 1978; *Le temps de
vieillir*, Paris: Denoël-Filipacchi, 1980; *Portraits*, Amiens: Trois Cailloux,
1988; *De temps en temps*, Paris: Les Petits Frères des Pauvres, 1988; *Le
Collège de France*, Paris: Imprimerie Nationale, 1995; *Jean Giono: The
Man Who Planted Trees*, New York: Limited Editions, 1995; *Tory Island
Images*, Dublin: Wolfhound Press, 1998; *One Day to the Next*, London:
Thames & Hudson; New York: Aperture, 1999; *Henri Cartier-Bresson
fotografato da Martine Franck*, Milan: Franco Sciardelli, 1998; *Tibetan
Tulkus: Images of Continuity*, London: Rossi & Rossi, 2000; *Martine
Franck Photographe*, Paris: Adam Biro, 2002; *Fables*, Arles: Actes Sud,
2004; *Agustin Cardenas fotografato da Martine Franck*, Milan: Franco
Sciardelli, 2006; *Martine Franck: Photo Poche*, Arles: Actes Sud, 2007;
Martine Franck, London: Phaidon, 2007

19. Le Brusc, France, 1976.

STUART FRANKLIN

Born 1956. British. Lives in Oxford. Joined Magnum in 1985.
Stuart Franklin began to take photographs at the age of
seventeen while travelling around Central and South
America. After studying geography at Oxford University
and photography at West Surrey College of Art and Design,
he began working for the British press in 1980. A full-time
freelance photographer from 1981 to 1985, he worked on a
project on the economic recession and unemployment in
Great Britain. In 1989, Stuart Franklin became famous for his
image of a Chinese student standing in front of the tanks in
Tiananmen Square, which won him a World Press Photo
award. During the 1990s, he collaborated with many
international newspapers and magazines: *The Sunday
Telegraph*, *Time*, *L'Express*, *El País*, *Newsweek* and most
prominently *National Geographic*. His documentary work
took him to Central and South America, to China and South-
East Asia. More recently, he has been interested in the growth
of cities and daily life in the urban environment, as well as
the effects of climate change. A Magnum Member since 1990,
Stuart Franklin was elected Magnum President in 2006.

Selected books:
Tiananmen Square, London: A.J. Vines, 1990; *The Time of Trees*, Rome:
Leonardo Arte, 2000; *La Città Dinamica*, Milan: Mondadori/Electa, 2003;
Sea Fever, Oxford: Bardwell Press, 2005; *Hotel Afrique*, Stockport: Dewi
Lewis, 2007; *Footprint: Our Landscape in Flux*, London: Thames &
Hudson, 2008

20. Tiananmen Square, Beijing, China, 1989.

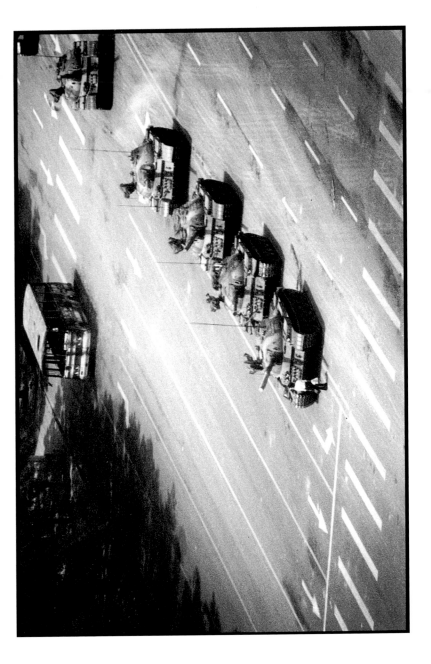

LEONARD FREED

1929–2006. American. Joined Magnum in 1956. Born into a working-class Jewish immigrant family from Eastern Europe, Leonard Freed originally set out to become a painter. After spending two years travelling in North Africa and Europe, particularly in the Netherlands where he began to take photographs in 1953, he returned to the US a year later and studied under the art director Alexey Brodovitch. He settled in Amsterdam in 1957 and became interested in the Jewish community. He first found acclaim through his work on the Civil Rights Movement in the US (1963–65). His status as a 'concerned photographer' was recognized in 1967 when he was invited to take part in the exhibition *The Concerned Photographer*, alongside Werner Bischof, Robert Capa and David 'Chim' Seymour. He covered the Six-Day War (1967) and the Yom Kippur War (1973), but it was through projects on German society (1965), the NYPD (1972–79) and the lives of practising Jews in several countries over a period of twenty-five years, that Leonard Freed best expressed himself and explored complex situations. He became a full Magnum Member in 1972. He also collaborated with many prestigious publications, including *Life*, *Paris Match*, *Der Spiegel*, *Stern*, *The New York Times Magazine* and *GEO*.

Selected books:
Joden van Amsterdam, Amsterdam: de Bezigebij, 1959; *Deutsche Jüden heute*, Frankfurt: Rütten & Leoning, 1965; *Black in White America*, New York: Grossman, 1967; *Seltsame Spiele*, Frankfurt: Barmier & Nikel, 1970; *Made in Germany*, New York: Grossman, 1970; *Leonard Freed's Germany*, London: Thames & Hudson, 1971; *Berlin*, Amsterdam: Time-Life Books, 1977; *Police Work*, New York: Simon & Schuster, 1980; *La Danse des fidèles*, Paris: Le Chêne, 1990; *New York Police: Photo Notes*, Paris: CNP, 1990; *Libertate Roumanie*, Paris: Denoël, 1990; *Leonard Freed: Photographs 1954–1990*, Manchester: Cornerhouse; New York: W.W. Norton, 1991; *Amsterdam: The Sixties*, Amsterdam: Focus, 1997; *Another Life*, Amsterdam: ABP Public Affairs, 2004; *Worldview*, Göttingen: Steidl, 2007

21. A young boy plays tough in the streets of Harlem, New York City, 1963.

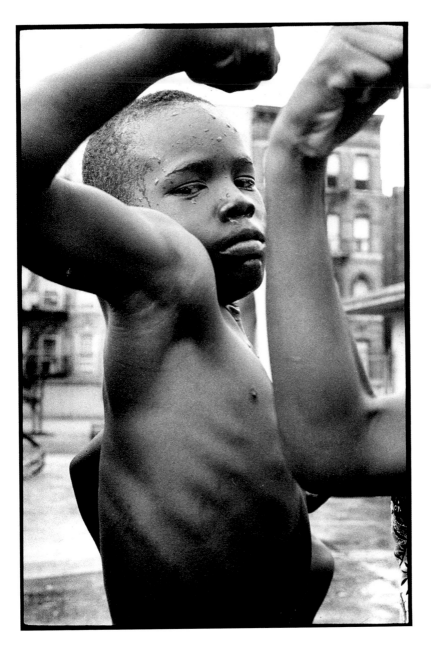

PAUL FUSCO

Born 1930. American. Lives in West Milford, New Jersey. Joined Magnum in 1973. Paul Fusco's interest in photography began when he was fifteen, and led to him becoming a US Army photographer during the Korean War (1951–53). After the war he studied photojournalism at Ohio University until 1957. He then moved to New York and worked as a photographer for *Look* magazine until 1971. During this long and intense period, he photographed miners in Kentucky, young runaways trying to survive in New York, and the African-American community in the Mississippi delta. He travelled widely, particularly to India and Latin America, where his reportages focused on social issues. Paul Fusco became a Magnum Member in 1974. In 1980, he moved to California, where he photographed the lives of the oppressed and those with alternative lifestyles. More recently, he has focused on people living with Aids, the issue of homelessness, and the dramatic repercussions of the Chernobyl explosion on the people of Belarus. Two of his recent exhibitions have had a major impact: *RFK Funeral Train* (2000) was a series of previously unpublished photographs taken in 1968 between New York and Washington DC, following the funeral convoy of Robert Kennedy after his assassination, while *Bitter Fruit* (2005) showed images from the funerals of US soldiers killed in the Iraq conflict; these photographs had been turned down by major US magazines but were published in *Mother Jones* in January 2005.

Selected books:

Sense Relaxation: Below the Mind, New York: Collier, 1968; *La Causa: The California Grape Strike*, New York: Collier, 1970; *What to Do Until the Messiah Comes*, New York: Collier, 1971; *The Photo Essay: Paul Fusco & Will McBride*, New York: Crowell; London: Thames & Hudson, 1974; *Marina & Ruby: Training a Filly with Love*, New York: William Morrow, 1977; *RFK Funeral Train*, New York: Umbrage/Magnum, 2000; *Chernobyl Legacy*, Milan: de.Mo, 2001

22. Novinki Asylum, Minsk, Belarus, 1997.

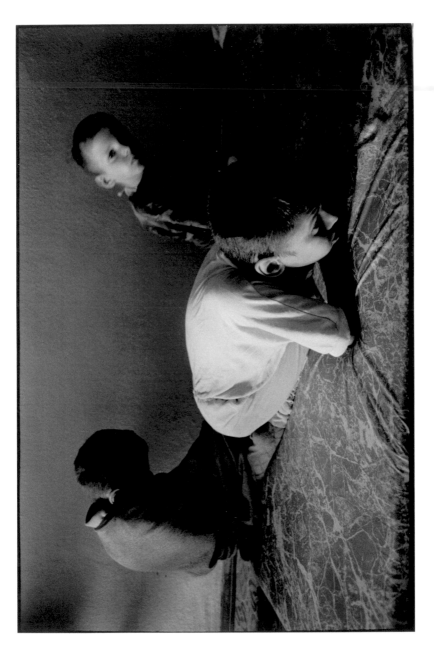

JEAN GAUMY

Born 1948. French. Lives in Fécamp. Joined Magnum in 1977. Originally from the southwest of France, Jean Gaumy worked as a sub-editor and photographer on a regional newspaper from 1969 to 1972, while studying for an arts degree at Rouen. In 1972 he submitted his first photographs to the Viva agency, then joined Gamma in 1973, and eventually Magnum in 1977. In 1975, he obtained permission to carry out a long-term project photographing the different departments inside a French hospital. The following year, he became the first photojournalist to be allowed inside the French prison system. He worked throughout Europe, Africa, Central America and the Middle East, notably in Iran which he visited frequently between 1986 and 1994. His photograph of Iranian women engaged in shooting practice during the Iran–Iraq War brought him international recognition. His interest in rural and coastal regions has led him to take many photographs of farmers and fishermen, including deep-sea trawlermen with whom he has regularly sailed. He published *Le Livre des tempêtes à bord de l'Abeille Flandre* and also *Men at Sea*, and won the Prix Nadar for Photographer of the Year in 2001. He has also made several documentary films, including *La Boucane* (1994), *Jean-Jacques (Chronique villageoise)* (1987), *Marcel, prêtre* (1994), and *Sous-Marin* (2006). The latter film was a pioneering documentary made on board a nuclear submarine during a four-month secret defence mission.

Selected books:

L'Hôpital, Paris: Contrejour, 1976; *Les incarcérés*, Paris: Éd. de L'Étoile/Cahiers du Cinéma, 1983; *Le pont de Normandie*, Paris: Le Cherche Midi, 1994; *Le Livre des tempêtes à bord de l'Abeille Flandre*, Paris: Le Seuil, 2001; *Men at Sea*, New York: Harry N. Abrams, 2002

23. Mesa Grande, Salvadorian refugee camp, Honduras, 1985.

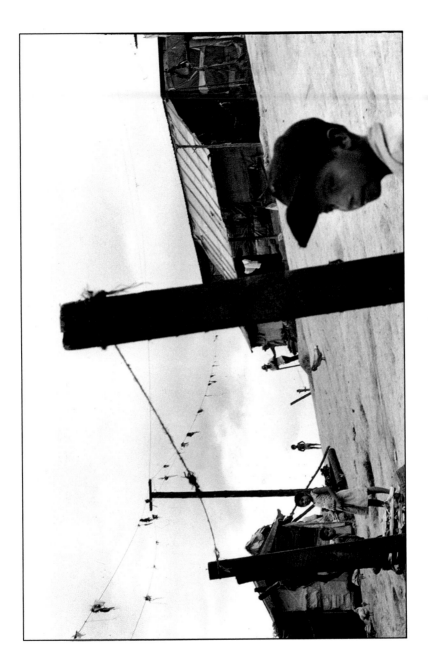

BRUCE GILDEN

Born 1946. American. Lives in New York. Joined Magnum in
1998. Bruce Gilden grew up in Brooklyn and built up a talent
for observing the customs and rituals of urban life. He began
as a student of sociology, but when his interest in photography
was awakened by seeing Michelangelo Antonioni's film *Blow
Up*, he began to take evening classes in photography at the
New York School of Visual Arts. His first major project, which
he worked on until 1986, was on New York's famous beach
resort of Coney Island. He then photographed New Orleans
and the Mardi Gras. In 1984 he began to photograph Haiti and
made regular trips there for ten years, while continuing to be
inspired by the streets of New York. These images, from 1981
on, were published in *Facing New York* (1992) and *A Beautiful
Catastrophe* (2005). He also photographed horseracing in
rural Ireland; *After the Off* (1999) juxtaposes his photographs
with a text by the Irish writer Dermot Healey. His following
book, *Go* (2000), gave a glimpse into the darker side of Japan,
with images of the homeless and Yakuza mobsters. Bruce
Gilden's work has been widely exhibited and selected for
major international collections, including New York MoMA,
the V&A in London, and Tokyo Metropolitan Museum of
Photography. He became a Magnum Member in 2002.

Selected books:

Facing New York, Manchester: Cornerhouse, 1992; *Bleus, Mission
photographique transmanche*, Douchy-les-Mines: CRP Nord-Pas-de-
Calais, 1994; *Haiti*, Stockport: Dewi Lewis, 1996; *After the Off*, Stockport:
Dewi Lewis, 1999; *Go*, London: Trebruk/Magnum, 2000; *Coney Island*,
London: Trebruk, 2002; *A Beautiful Catastrophe*, New York: Powerhouse,
2005; *Fashion Magazine*, New York: Magnum Photos, 2006

24. New York City, USA, 1984.

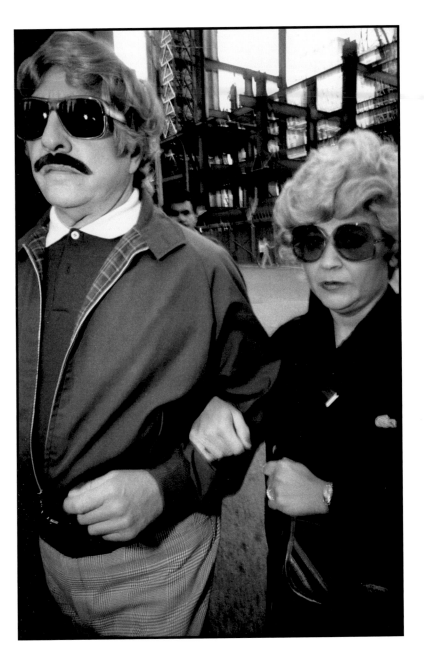

BURT GLINN

Born 1925. American. Lives in New York. Joined Magnum
in 1951. Drafted into the US Army during the Second World
War, Burt Glinn studied at Harvard (1946–49), then worked
for *Life* magazine (1949–50) before becoming a freelance
photographer in 1950. Based in Seattle from 1952 to 1955,
he began to travel worldwide, and became a Magnum
Member in 1954. In 1959 he photographed the revolution in
Cuba, including the arrival of Fidel Castro in Havana. He
was also interested in Russia and Japan, which became the
subjects of two books published in the late 1960s. He worked
for magazines including *Holiday*, *Life*, *Paris Match* and *GEO*,
and also produced annual reports for major US corporations.
Burt Glinn's many awards include Missouri University's
Mathew Brady Award for Magazine Photographer of the
Year in 1959. He has twice been elected President of Magnum,
in 1972 and 1987.

Selected books:

The Dark Eye in Africa, New York: William Morrow, 1955; *A Portrait of All
the Russias*, New York: William Morrow, 1967; *A Portrait of Japan*, New
York: William Morrow, 1968; *Havana: The Revolutionary Moment*, New
York: Umbrage, 2001

25. Fidel Castro, Palacio Municipale, Santa Clara, Cuba, January 1959.

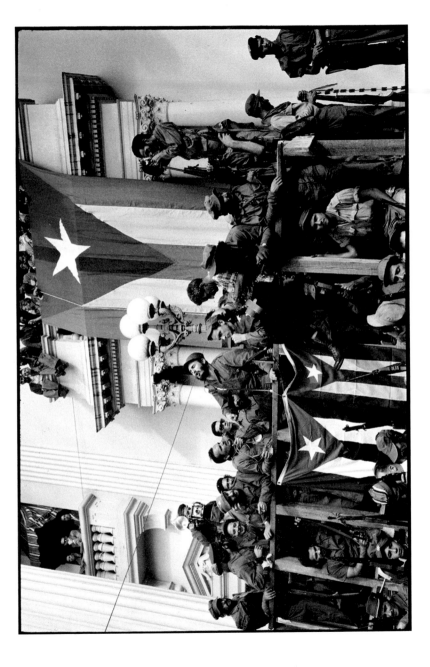

JIM GOLDBERG

Born 1953. American. Lives in San Francisco. Joined Magnum in 2002. A Member of Magnum since 2006, Jim Goldberg is also a professor of art at California College of Arts and Crafts. In his series *Rich and Poor* (1977–85), he invented a new way to tell a story by combining text and images. These portraits of the residents of welfare hotels and of large upper-class homes made a statement about the nature of the American Dream, the class struggle, power and the pursuit of happiness. In *Raised by Wolves* (1985–95), he followed teenage runaways on the streets of Los Angeles and San Francisco and created a book and exhibition that combined photographs, texts, notes, snapshots, found objects and even sculptures. He is currently working on two new book projects, one based on an autobiographical piece of fiction, the other on immigration and human trafficking in Europe. Jim Goldberg has won many awards, including the Guggenheim Fellowship and the Hasselblad Award. Over twenty-five years, his work has been widely exhibited and features in the collections of major US museums. He is represented by Pace/MacGill Gallery in New York and the Stephen Wirtz Gallery in San Francisco.

Selected books:

Rich and Poor, New York: Random House, 1985; *Raised by Wolves*, Zurich and New York: Scalo, 1995; *Hospice: A Photographic Inquiry* (with Nan Goldin, Sally Mann, Jack Radcliffe and Kathy Vargas), Boston: Little, Brown, 1996; *It Ended Sad But I Love Where It All Began*, Oakland, CA: These Birds Walk, 2007

26. Victim of human trafficking, Ternopil, Ukraine, 2007.

MY LIFE is
SICK BECAUSE
of WHAT
THEY DID
TO ME

Моє життя
зіпсоване зараз
через те, що
вони зробили
зі мною

PHILIP JONES GRIFFITHS

Born 1936. Welsh. Lives in New York. Joined Magnum in 1966.
Philip Jones Griffiths studied pharmacy at Liverpool University
in the 1950s and became a part-time photographer for the
Manchester *Guardian* and Granada Television. He gave up
pharmacy to become a full-time photographer and worked
for *The Observer* in London from 1961 to 1963. He documented
the Vietnam War in several reportages (1966–70), and his book
Vietnam Inc. (1977) was considered one of the most important
photographic works on that conflict. It sold out within a few
weeks, shook public opinion and played a key role in the
peace process. A Magnum Member since 1971, Philip Jones
Griffiths covered the Yom Kippur War in 1973 and then worked
in Cambodia, before basing himself in Thailand in 1977.
In 1980 he moved to New York to become President of
Magnum, a post he held until 1985. His photographs have
been published in the world's greatest magazines and his
work has taken him to more than 120 countries. Through his
photographs, writings and films, he continues to reflect on the
unequal relationship between humanity and technology, as
well as the devastating effects of war, as documented in his
book *Agent Orange* (2003).

Selected books:
Vietnam Inc., New York: Collier, 1971; *Bangkok*, Amsterdam: Time-Life
Books, 1979; *Philip Jones Griffiths: Una visión retrospectiva (1952–1988)*,
Madrid: Consorcio para la Organización de Madrid Capital Europea
de la Cultura, 1992; *Dark Odyssey*, New York: Aperture, 1996; *Agent
Orange: Collateral Damage in Vietnam*, London: Trolley, 2003;
Vietnam at Peace, London: Trolley, 2005

27. South Korea, 1967.

HARRY GRUYAERT

Born 1941. Belgian. Lives in Paris. Joined Magnum in 1981.
After studying at the Brussels School of Film and Photography
(1959–62), Harry Gruyaert became a fashion and advertising
photographer as well as a director of photography for Belgian
TV until 1967. In 1969, he made his first of many visits to Morocco.
In 1972 he moved to London. He photographed the Munich
Olympics, and also the Apollo spaceflights on a TV screen,
manipulating the colours. This series, *TV Shots*, was exhibited
at the Delpire Gallery and helped Harry Gruyaert to discover
a new creative approach. In 1975 he began a project on
Belgium, which was eventually turned into the book *Made
in Belgium* (2000). In 1976 he won the Kodak Prize for his
work on Morocco, and further travels took him to Egypt, India,
Vietnam and Yemen. For more than twenty years, he has
captured the subtle colours of light in both the East and the
West, but is also fascinated by the atmosphere of major cities.
He favours long-term projects that are free from commercial
constraints, and pays meticulous attention to detail in all the
books and exhibitions that take his images around the world.
He has been a Magnum Member since 1986.

Selected books:
Lumières blanches, Paris: CNP, 1986; *Morocco*, Munich and New York:
Schirmer/Mosel, 1990; *Made in Belgium*, Paris: Nathan/Delpire, 2000;
Rivages, Paris: Textuel, 2003; *Harry Gruyaert: Photo Poche*, Arles: Actes
Sud, 2006; *TV Shots*, Göttingen: Steidl, 2007

28. Valley of the Kings, left bank of the Nile, village of New Guerna, Egypt, 1992.

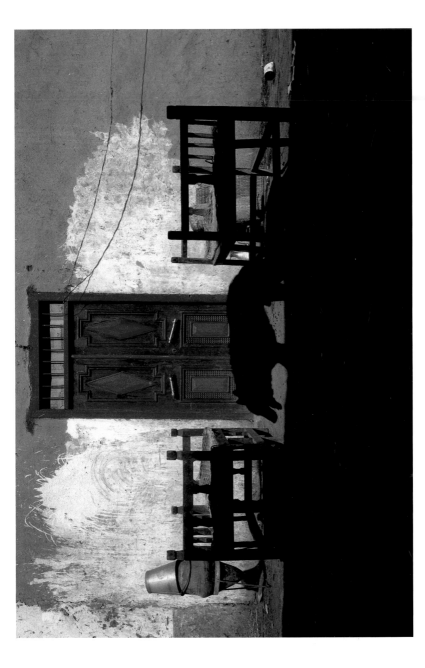

PHILIPPE HALSMAN

1906–79. American. Joined Magnum in 1951. Philippe Halsman was born in Riga in Latvia, and studied electrical engineering in Dresden, Germany, before settling in Paris where he became a photographer. He opened a studio in Montparnasse in 1934 and photographed figures from the art world, including Chagall, Malraux, Le Corbusier and Gide, using a twin-lens reflex camera that he designed himself. When the Nazis occupied France in 1940 he fled the country and obtained a US visa with the help of Albert Einstein. He settled in New York with his wife and two daughters. Less than two years after his arrival, his work was featured on the front cover of *Life* magazine, the first of more than 100 covers for them. He also began a collaboration with Salvador Dalí that lasted thirty-seven years. In 1945 he was elected President of the American Society of Magazine Photographers. In 1949, his first book, *The Frenchman*, devoted entirely to Fernandel, was published and became a bestseller. He was invited to join Magnum in 1951 and became a Contributor from 1956. It was during this period that he began his famous series in which celebrities jump for the camera, first for the NBC image bank and then for *Life*. The series was published as *Philippe Halsman's Jump Book* in 1959. These witty and dynamic images represent a major part of his work. Philippe Halsman died in New York in 1979, at the age of 73.

Selected books:

The Frenchman, New York: Simon & Schuster, 1949; *Piccoli, A Fairy Tale*, New York: Simon & Schuster, 1953; *Dalí's Mustache*, New York: Simon & Schuster, 1954; *Philippe Halsman's Jump Book*, New York: Simon & Schuster, 1959; *Halsman on the Creation of Photographic Ideas*, New York: A.S. Barnes & Co., 1961; *Sight and Insight*, Garden City, NY: Doubleday, 1972; *Halsman '79*, New York: ICP, 1979; *Halsman: Portraits*, New York: McGraw-Hill, 1983; *Philippe Halsman's Jump Book*, reprint, New York: Harry N. Abrams, 1986; *Halsman at Work*, New York: Harry N. Abrams, 1989; *Dalí's Mustache*, reprint, Paris: Flammarion, 1994; *Philippe Halsman: A Retrospective*, Boston: Bulfinch Press, 1998; *The Frenchman*, reprint, London: Taschen, 2006

29. Salvador Dalí, New York City, USA, 1951.

ERICH HARTMANN

1922–99. German, naturalized American. Joined Magnum in 1952. Born in Munich, Erich Hartmann was sixteen years old when his family emigrated to the USA in 1938, to escape the Nazi regime. They settled in Albany in the state of New York, and young Erich was the only English-speaker in the family. He worked in a textile mill during the day and continued his studies in the evening. During the Second World War, he served in the US Army in Europe. In 1946, he moved to New York where he became assistant to a portrait photographer, and then a freelance photographer. Throughout his career, Erich Hartmann favoured long-term personal projects over short reportages, as seen in his series *The World of Work*, *Our Daily Bread*, and his photographic essays based on literary works by William Shakespeare, James Joyce and Thomas Hardy. He also explored the field of abstraction through his photographs of electronic components and ink drops in water. His book *In The Camps* (1995) contained his images of the Nazi concentration camps, and the book and the exhibitions that followed were seen all over Europe and North America. A Member of Magnum since 1954, he was elected President in 1985 and became a Contributor in 1994. Right up to his death in 1999, he was working on a project entitled *Music Everywhere*.

Selected books:
Our Daily Bread, Pillsbury Co., 1962; *Space: Focus Earth*, Brussels: Arcade, 1972; *In The Camps*, New York and London: W.W. Norton, 1995; *Where I Was*, Salzburg: Otto Müller, 2000

30. New York City, 1977.

DAVID ALAN HARVEY

Born 1944. American. Lives in New York. Joined Magnum in
1993. Born in San Francisco, David Alan Harvey grew up in
Virginia and discovered photography at the age of eleven.
He bought a second-hand Leica and began to photograph
his family and neighbourhood in 1956. At the age of twenty,
he started to photograph the daily life of a black family from
Norfolk, Virginia, which was published as the small book
Tell It Like It Is in 1966. In the early 1970s, he began working
for *National Geographic*, producing more than forty photo
essays. The National Press Photographers Association named
him Magazine Photographer of the Year in 1978. His two best-
known books are entitled *Cuba* (1999) and *Divided Soul* (2003),
on the subject of the combining of cultures and Hispanic
migration throughout Latin America. David Alan Harvey
has been a Magnum Member since 1997.

Selected books:
The Mysterious Maya, Washington DC: National Geographic Society,
1977; *Virginia*, Portland, OR: Graphic Arts Center, 1981; *America's
Atlantic Isles*, Washington DC: National Geographic Society, 1981;
Cuba, Washington DC: National Geographic Society, 1999; *Divided
Soul*, London and New York: Phaidon, 2003; *Living Proof*, Brooklyn, NY:
Powerhouse, 2007

31. Strip club, New York, 2005.

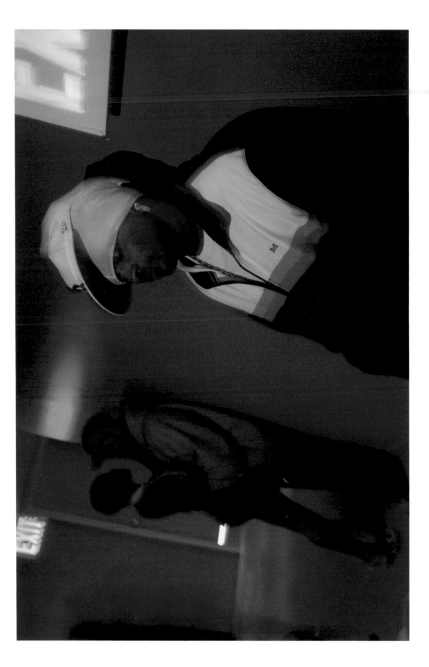

THOMAS HOEPKER

Born 1936. German. Lives in New York. Magnum have
distributed his images since 1964. Joined Magnum in 1989.
After studying art history and archaeology in Göttingen
and Munich (1956–59), Thomas Hoepker became a contract
photographer for *Münchner Illustrierte* and then *Kristall*
(1960–62). He reported from all over the world and joined *Stern*
magazine in 1964. A freelance photographer from 1968, he
also worked as a documentary producer and cameraman for
German TV from 1972. From 1973 he began to collaborate with
Stern once more on various projects. In 1974 he worked with
his first wife Eva, a journalist, in East Germany and in 1976
moved to New York as a *Stern* correspondent. From 1978 to
1981 he was director of photography for the US edition of *GEO*.
After 1981, he turned freelance once more, then became art
director for *Stern* in Hamburg from 1987 to 1989. He became a
Magnum Member in 1989 and its President from 2003 to 2006.
Thomas Hoepker, who specializes in colour photography, has
won many awards for his work, including the Kulturpreis from
the Deutsche Gesellschaft für Photographie in 1968.

Selected books:
Jugend in dieser Zeit, Stuttgart: Steingrüben, 1957; *Yatun Papa: Father
of the Indians, Dr Theodor Binder*, Stuttgart: Kosmos, 1963; *Leben in der
DDR*, Hamburg: Sternuch, 1976; *Heinz Mack: Expedition in Künstliche
Gärten*, Hamburg: Sternbuch, 1977; *Vienna*, Amsterdam: Time-Life
Books, 1978; *Die New York Story*, Munich: Geo Buch, 1983; *Ansichten*,
Heidelberg: Braus, 1985; *New Yorker: 50 aussergewöhnliche Foto- und
Textporträts*, Schaffhausen: Stemmle, 1987; *Rome*, Hamburg: Hoffmann
& Campe, 1988; *Land der Verzauberung: Santa Fe, New Mexico*,
Hamburg: Philip Morris Books, 1991; *Return of the Maya: Guatemala,
A Tale of Survival*, Albany, NY: Henry Holt; Stockport: Dewi Lewis,
1998; *Thomas Hoepker: Photographien 1955–2005*, Munich:
Schirmer/Mosel, 2005

32. Spanish Duchess at a wedding in the town of Jerez, Spain, 1964.

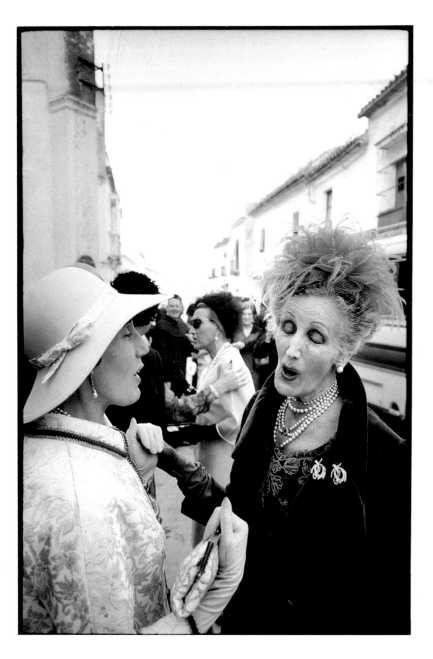

DAVID HURN

Born 1934. British. Lives in Wales. Joined Magnum in 1965. After attending the Royal Military Academy at Sandhurst (1952–54), David Hurn joined the Reflex Agency in London as an assistant (1955–57). His first report on the 1956 revolution in Hungary gained him an international reputation. A freelance photographer from 1957 to 1970, he became a Magnum Member in 1967 and moved to Wales in 1971, where he worked on personal projects. From 1973 to 1990 he ran the School of Documentary Photography in Newport, Wales, and was also an adviser to the Arts Council of Great Britain (1972–77). While he continues to travel the world, David Hurn has spent more than thirty-five years documenting Wales in all its aspects. Of Welsh descent on his father's side, he has captured the economic and industrial changes in this land that was, until fairly recently, dominated by agriculture and coalmining. This transformation was documented in his books from the early 2000s.

Selected books:
Wales: Black & White, London: Arts Council of Great Britain, 1976; *David Hurn: Photographs 1956–1976*, London: Arts Council of Great Britain, 1979; *Arizona Trip*, London: Olympus Cameras Centre, 1982; *Up To Date*, Cardiff: Ffotogallery, 1984; *On Being a Photographer*, Portland, OR: Lenswork Publishing, 1997; *On Looking at Pictures*, Portland, OR: Lenswork Publishing, 2000; *Wales: Land of My Father*, London: Thames & Hudson, 2000; *Living in Wales*, Bridgend: Seren, 2003; *Rebirth of a Capital*, Cardiff: Cardiff County Council, 2005

33. The Welsh Proms at St David's Hall, Cardiff, Wales, 2004.

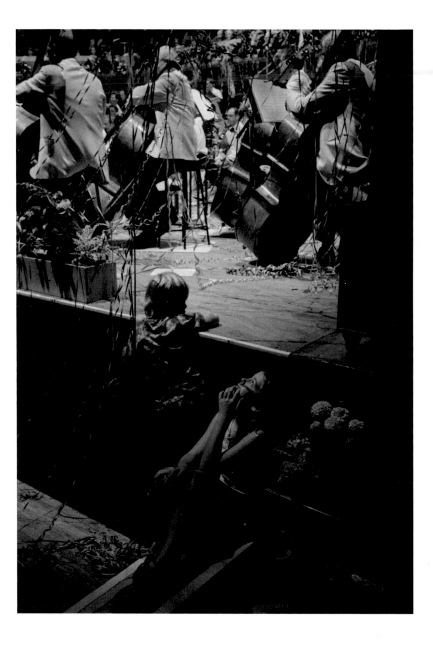

RICHARD KALVAR

Born 1944. American. Lives in Paris. Joined Magnum in 1975.
After studying English and American literature at Cornell
University (1961–65), Richard Kalvar became assistant to the
fashion photographer Jérôme Ducrot in New York. It was a
long period spent travelling in Europe with his camera that
led him to decide on a career in photography. After two
years in New York, he moved to Paris and joined the Vu
agency, before becoming a founder member of the Viva
agency in 1972. In 1977 he became a Magnum Member, later
serving as President and several times as Vice-president.
He travelled throughout the US, Europe and Japan and
produced photo essays on daily life, playing on the
ambiguous relationship between appearance and reality.
His prolific body of work includes both personal projects and
commissions. Since 1997 he has been a regular attendee at
the World Economic Forum in Davos, Switzerland. In 2007 his
first major retrospective, entitled *Terriens (Earthlings)*, was
held at the Maison Européenne de la Photographie in Paris.
He is engaged in a long-term photography project in Rome.

Selected books:
Familles en France, Paris: Viva, 1973; *Album Photographique 1*, Paris:
Centre Georges-Pompidou, 1979; *L'Usine*, Paris: Colgate-Palmolive,
1987; *Portrait de Conflans-Sainte-Honorine*, Paris: Calmann-Lévy, 1993;
Terriens, Paris: Flammarion, 2007

34. Jardin du Luxembourg, Paris, 2000.

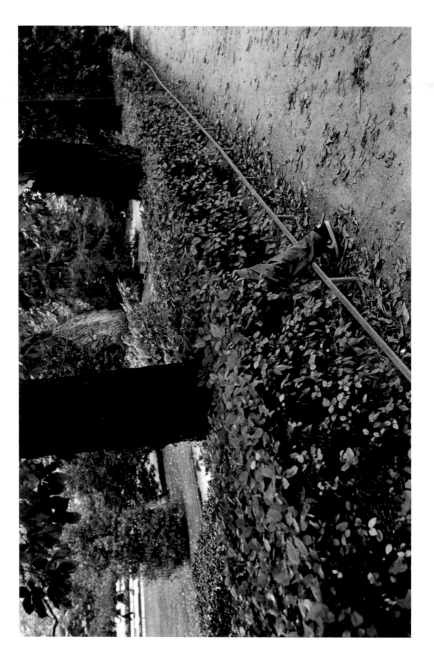

CARL DE KEYZER

Born 1958. Belgian. Lives in Ghent. Joined Magnum in 1990.
After studying film and photography at the Koninklijke
Academie voor Schone Kunsten in Ghent, Carl de Keyzer
became a freelance photographer and also a teacher at the
same institution, from 1982 to 1989. He also founded the XYZ
Photography Gallery in Ghent. The publication of his images
of India in 1987 brought him international recognition. His
reputation was further boosted by *Homo Sovieticus* (1989),
on the fall of the Soviet Union, and *God, Inc.* (1992), on the link
between patriotism and religious faith in the USA. He became
a Magnum Member in 1994. In 1996, Carl de Keyzer explored
the remaining traces of the Communist bloc and published
East of Eden. Finally, *Zona* (2003) brought together a series
of photographs taken in Siberian prison camps. Among his
awards are the Book Prize at the Rencontres d'Arles and the
W. Eugene Smith Award in 1990. His work has been exhibited
in many European museums.

Selected books:
Oogspanning, Ghent: Carl de Keyzer, 1984; *India*, Amsterdam: Focus,
1987; *USSR – 1989 – CCCP*, Amsterdam: Focus; The Hague: SDU, 1989;
Homo Sovieticus, Amsterdam: Focus, 1989; *God, Inc.*, Amsterdam:
Focus, 1992; *East of Eden*, Ghent: Ludion, 1996; *Tableaux d'histoire*, Paris:
CNP, 1997; *Europa*, Ghent: Ludion, 2000; *Zona*, London: Trolley, 2003

35. Gathering of bikers, Daytona Beach, Florida, USA, 1990.

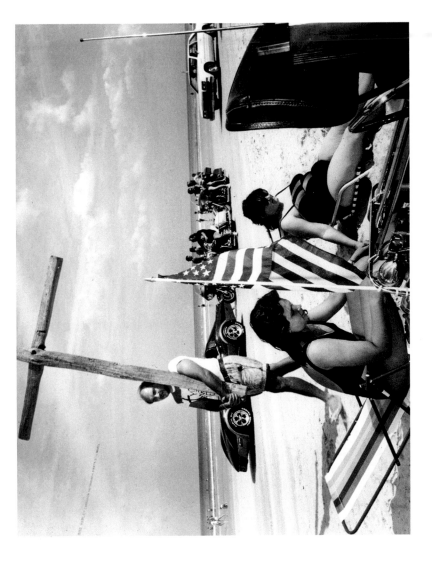

JOSEF KOUDELKA

Born 1938. Czech, naturalized French. Lives in Paris and Prague. Joined Magnum in 1971. After studying at the Technical University in Prague (1956–61), he worked as an aeronautics engineer, at the same time photographing Czechoslovakian theatre and gypsies. His images of Russian tanks arriving in Prague in 1968 were distributed anonymously and won him the Robert Capa Gold Medal the following year. Following the death of Koudelka's father, these photographs were credited to their creator for the first time in 1984. In 1970, Koudelka sought asylum in Great Britain and became stateless. An exhibition of his work was held at MoMA in New York in 1975, the year that his book *Gypsies* was published. In 1980 he moved to Paris and became a naturalized Frenchman in 1987. In 1986 he took part in the DATAR project, photographing the French countryside and began to use a panoramic camera for the first time. In 1990 he returned to Cezchoslovakia and took panoramic images of the most devastated landscape in Europe, the Black Triangle. His reflections on the solitude of mankind in the face of environmental changes led to the book *Chaos* (1999). Josef Koudelka has received many awards, including the Grand Prix National de la Photographie in France (1989), the Cartier-Bresson Prize (1991) and the ICP Infinity Award (2004). He has been a Magnum Member since 1974.

Selected books:
Diskutujeme o morálce dneska, Prague: Svoboda, 1965; *Gitans: La fin du voyage/Gypsies*, Paris: Delpire; Millerton, NY: Aperture, 1975; *Exils/Exiles*, Paris: CNP; New York: Aperture; London: Thames & Hudson, 1988; *Mission Photographique Transmanche, Cahier no. 6*, Douchy-les-Mines: CRP Nord-Pas-de-Calais, 1989; *Prague, 1968: Photo Notes*, Paris: CNP, 1990; *Fotografie, Divadlo Za Branou, 1965–1970*, Prague: Divadlo Za Branou, 1993; *The Black Triangle – The Foothills of the Ore Mountains: Photographs 1990–1994*, Prague: Vesmir, 1994; *Reconnaissance: Wales*, Cardiff,: Ffotogallery 1998; *Chaos*, Paris: Nathan-Delpire; London: Phaidon, 1999; *Limestone (Lhoist)*, Paris: La Martinière, 2001; *Teatro del tempo*, Rome: Peliti, 2003; *L'épreuve totalitaire*, Paris: Delpire, 2004; *Josef Koudelka: Photofile*, London: Thames & Hudson, 2006; *Koudelka*, New York: Aperture; London: Thames & Hudson, 2006; *Invasion Prague 68*; London: Thames & Hudson, 2008

36. Parc de Sceaux, France, 1987.

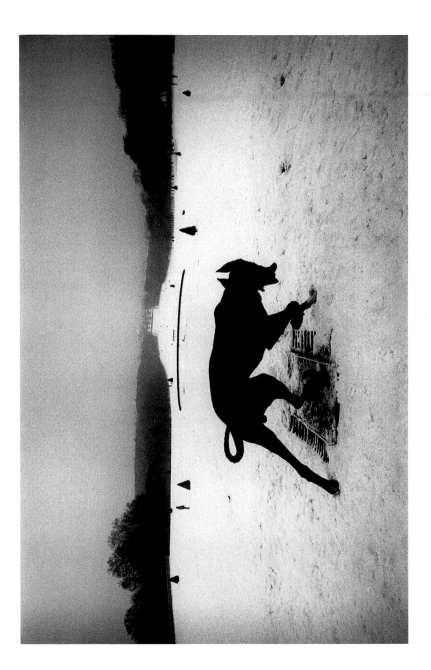

HIROJI KUBOTA

Born 1939. Japanese. Lives in Odawara, near Tokyo. Joined
Magnum in 1971. A graduate in political science from Waseda
University in Tokyo in 1962, Hiroji Kubota went to the US to
continue his studies. A freelance photographer from 1965,
he returned to live in Japan in 1968. In 1978, he began to
photograph North Korea, and the following year, China.
He has received many prizes in Japan, including the
Kodansha Publishing Culture Award in 1970, the Nendo
Sho (Annual Award) from the Photographic Society of Japan
in 1982, and the Mainichi Art Prize in 1983. He continues to
take photographs in most Asian countries and is particularly
interested in the consequences of population explosion,
poverty and environmental damage in this rapidly growing
part of the world. His most recent book was devoted to Japan,
where he still works. Hiroji Kubota has been a Magnum
Member since 1986.

Selected books:

Guilin Fantasy, Tokyo: Iwanami Shoten, 1982; *China*, New York and
London: W.W. Norton, 1985; *The Mountains of North Korea: Mts Paekdu
and Kumgang*, Tokyo: Iwanami Shoten, 1988; *From Sea to Shining Sea:
A Portrait of America*, New York and London: W.W. Norton, 1992; *Out of
the East: Transition and Tradition in Asia*, New York and London:
W.W Norton, 1998; *Can We Feed Ourselves?: A Focus on Asia*, New York:
Magnum Photos, 2000; *Japan*, New York and London: W.W. Norton, 2004

37. Shwe Pyi Daw, a Buddhist holy site, near Kyakito.
Mon, Myanmar, 1978.

SERGIO LARRAIN

Born 1931. Chilean. Lives in Chile. Joined Magnum in 1959.
Sergio Larrain grew up in Santiago de Chile in a family that
were devoted to the arts and culture; his father was one of the
great South American architects and was a friend of the artists
Josef Albers and Roberto Matta. He studied water and forestry
at Berkeley in California (1949–53), during which time he
bought his first camera, and at the University of Michigan
in Ann Arbor. He then travelled throughout Europe and
the Middle East. In 1954, he returned to Chile and became
a freelance photographer. He worked for the Brazilian
magazine O Cruzeiro in 1956 and 1957, travelled through
Latin America and then arrived in Europe as a freelancer.
In 1958 he received a British Council bursary which enabled
him to stay in London to work. He also met Henri Cartier-Bresson
who encouraged him to join Magnum; he became a Member
in 1961. He returned to Chile, where the poet Pablo Neruda
invited him to his home in Isla Negra, by the Pacific Ocean;
there he photographed Neruda and his surroundings. The
two met once again to work on an essay on Valparaíso.
Published in the Swiss magazine Du, this series of photographs,
predominantly taken in 1963, were later collected in a book
called Valparaíso, published in 1991. The publication of this
book was accompanied by an exhibition at the Rencontres
d'Arles. In the early 1960s he began to practise meditation
under the direction of the Bolivian spiritual teacher Oscar
Ichazo, who founded the Arica school in northern Chile.
In 1971, Sergio Larrain decided to distance himself from
Magnum and photography, in order to devote most of his
time to painting, meditation and yoga. A major exhibition
of his work was held in 1999 at IVAM in Valencia, Spain.

Selected books:
El Rectángulo en la mano, Santiago de Chile: Cardenos Brasileiros,
1963; Una casa en la arena, Barcelona: Lumen, 1966; Chili, Lausanne:
Rencontre, 1968; Valparaíso, Paris: Hazan, 1991; London, Stockport:
Dewi Lewis, 1998; Sergio Larrain, Valencia: IVAM, 1999

38. Valparaíso, Chile, 1957.

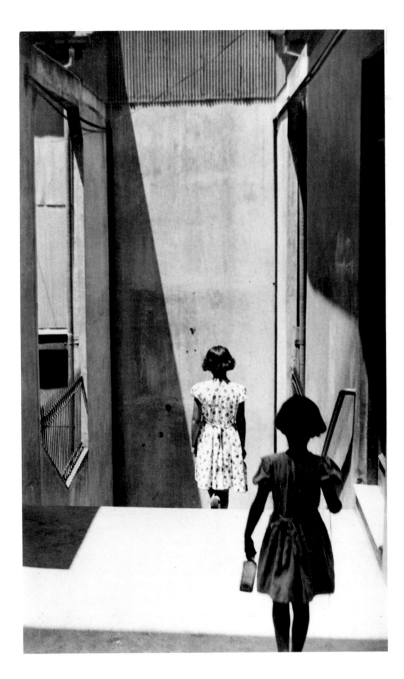

GUY LE QUERREC

Born 1941. French. Lives in Paris. Joined Magnum in 1976.
Guy Le Querrec was born in Paris and took his first
photographs at the age of thirteen. In 1969 he was hired by
the magazine *Jeune Afrique*, and spent two years travelling
frequently in French-speaking Africa. In 1971, he joined the
Vu agency. A founder member of the Viva agency in 1972,
he left in 1975 and became a Magnum Member in 1977. As
well as his reportage work, he created several shows that
combined live jazz improvisation with photography: *De l'eau
dans le jazz* (Rencontres d'Arles, 1983) and *Jazz comme une
image* (Rencontres d'Arles/Banlieues Bleues, 1993). Since 1980
he has been involved in some thirty documentary films about
jazz, most of them directed by Frank Cassenti. Following tours
of Africa by Aldo Romano, Henri Texier and Louis Sclavis, a
trio that he brought together, Label Bleu published box sets
containing CDs and photo booklets of their travels: *Carnet de
routes* (1995), *Suite africaine* (1999). The final instalment in this
trilogy was *African Flashback* (2005), containing a selection
of photographs taken between 1968 and 1998. Since 1975
Guy Le Querrec has taught regularly both in France and
abroad. In 2006 he was chosen as a 'travelling companion'
by Raymond Depardon for the Rencontres d'Arles, and
created an exhibition, performance and teaching course
under the title *L'Oeil de l'Éléphant*.

Selected books:
Quelque part, Paris: Contrejour, 1977; *Portugal 1974–75: Regards sur
une tentative de pouvoir populaire*, Paris: Hier et Demain, 1980; *Jazz sous
les platanes*, Vitrolles: Java, 1984; *Tête à tête: Daniel Druet, un sculpteur
et ses modèles*, Paris: Carrère, 1988; *Musicales*, Amiens: Trois Cailloux,
1991; *Jazz comme une image*, Paris: Scandéditions, 1993; *Carnet de
routes* (CD & book), Paris: Label Bleu, 1995; *Jazz de J à ZZ*, Paris: Marval,
1996; *François Mitterrand: Des temps de poses à l'Elysée*, Paris: Marval,
1997; *Suite africaine: Carnet de routes* (CD & book), Paris: Label Bleu,
1999; *Jazz: Light and Day*, Milan: Motta, 2001; *On the Trail to Wounded
Knee: The Big Foot Memorial Ride*, Guilford, CT: The Lyons Press, 2002;
African Flashback (CD & book), Paris: Label Bleu, 2005

39. Cheyenne River reservation, north fork of the Bad River, Haakon County,
South Dakota, USA, 1990.

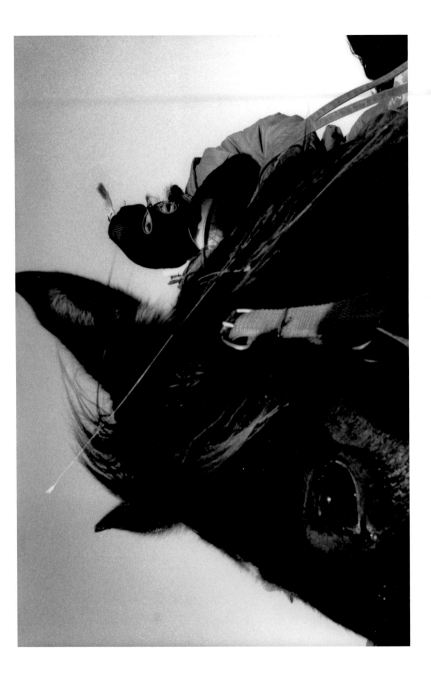

ERICH LESSING

Born 1923. Austrian. Lives in Vienna. Joined Magnum in 1951. Following the Nazi occupation of Austria in 1939, Erich Lessing was obliged to emigrate to Palestine, then under British rule. He studied at the technical college in Haifa, while working as a driver and a fish-farmer in a kibbutz and also learning photography. During the Second World War he served in the British Army as a photographer in the Parachute Regiment. In 1947 he returned to Vienna and produced reportages for the Associated Press. In the early 1950s he met David 'Chim' Seymour in Strasbourg, which led to him becoming a Magnum Member in 1955. He photographed current events in North Africa and Europe, including the revolution in Hungary in 1956. From the 1960s on, he devoted himself to recording historical events and major political figures in many books on art and history. In parallel to this prolific published output – now numbering more than forty books – he has also taught photography since 1974. His awards include the Prix Nadar in 1966, for *The Voyages of Ulysses*. A specialist in documenting cultural heritage, he is a member of the International Council of Museums (ICOM-UNESCO).

Selected books:

Szene: ein Bildwerk über die Staatsoper und das Burgtheater, Vienna: Staatsdruckerei, 1954; *Imago Austriae*, Vienna: Herder, 1963; *The Voyages of Ulysses*, Freiburg: Herder, 1965; *Deutsche Reise*, Vienna: Herder, 1969; *L'Opéra de Paris*, Paris: Hatier, 1975; *Die Kelten*, Freiburg: Herder, 1979; *The Travels of St Paul*, New York: Herder & Herder, 1980; *Griechenland*, Stuttgart and Berlin: Kohlhammer, 1988; *Florence and the Renaissance: The Quattrocento*, New York: Stewart, Tabori, & Chang, 1993; *Fifty Years of Photography*, Vienna: Herder, 1994; *The Gods of Ancient Egypt*, New York: George Braziller, 1998; *Von der Befreiung zur Freiheit: Ein Photoalbum 1945–1960*, Vienna: Verlag der Metamorphosen, 2005; *Arresting Time: Reportage Photography 1948–1973*, New York: Quantuck Lane Press, 2005; *Revolution in Hungary: The 1956 Budapest Uprising*, London: Thames & Hudson, 2006

40. President Eisenhower, Geneva summit. Switzerland, 1955.

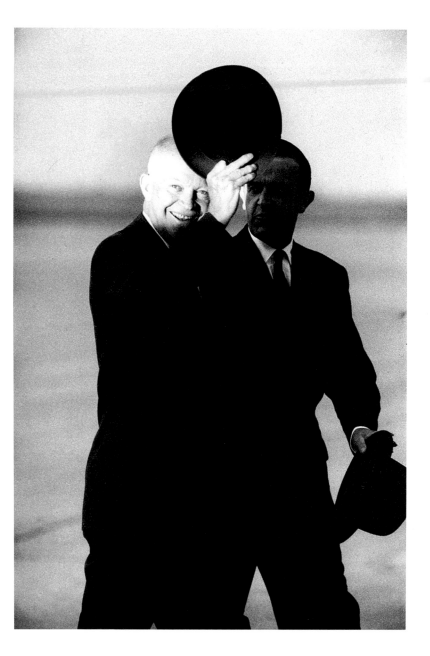

ALEX MAJOLI

Born 1971. Italian. Lives in New York and Milan. Joined
Magnum in 1996. At the age of fifteen he became an
apprentice and worked at the F45 studio in his home town of
Ravenna, working with the photographer Daniele Casadio.
While studying at the Ravenna school of fine arts, he joined
the Italian agency Grazia Neri in 1990 and travelled several
times to the former Yugoslavia to cover the conflict there.
In 1994, he photographed the Leros psychiatric institution
in Greece just before its closure; this project was published
in the book *Leros* (2002). In 1995, he went to South America
for several months and photographed various subjects for
an ongoing project called *Requiem in Samba*. In 1998, he
began another series, *Hotel Marinum*, visiting ports all over
the world. In the same year, he also began to make short
films and documentaries. A Magnum Member since 2001,
he covered the war in Afghanistan following the tragedy of
September 11. Alex Majoli has photographed international
conflicts for magazines including *Newsweek*, *The New
York Times Magazine* and *Granta*. He also took part in the
exhibition and installation *Off Broadway*, along with Thomas
Dworzak, Paolo Pellegrin and Ilkka Uimonen, in New York
then in Europe, and is currently working on several projects,
including one with the French Ministry of Culture on the
social transformation of the city of Marseilles.

Selected books:
Leros, London: Trolley, 2002; *One Vote*, Paris: Filigranes, 2004

41. Death of a US soldier, Iraq, 8 April 2003.

STEVE McCURRY

Born 1950. American. Lives in New York. Joined Magnum in 1985. Born in Philadelphia, Steve McCurry graduated with honours from the College of Arts and Architecture at Penn State University. After working for a newspaper for two years, he set off for India. His career was launched when he crossed the Pakistani border, dressed in local costume, to enter rebel-controlled Afghanistan, shortly before the Russian invasion. When he returned, with film canisters sewn into his clothes, his photographs were published all over the world and were some of the first to show this conflict. This work won him the Robert Capa Gold Medal. Steve McCurry has gone on to cover civil and international conflict in many locations: Beirut, Cambodia, the Philippines, the former Yugoslavia, and the Gulf War. He returns regularly to Afghanistan and to Tibet. His work appears regularly in many major magazines, including *National Geographic*. It was while working for this magazine that he achieved one of the high points of his career when he successfully tracked down Sharbat Gula, a young Afghan refugee that he had famously photographed twenty years earlier, creating an iconic image. Steve McCurry has won many awards, including the Magazine Photographer of the Year from the National Press Photographers Association. In 1985 he won four first prizes at the World Press Photo awards, and has twice received the Olivier Rebbot Memorial Prize.

Selected books:

The Imperial Way (text by Paul Theroux), Boston: Houghton Mifflin, 1985; *Monsoon*, London: Thames & Hudson, 1988; *Portraits*, London and New York: Phaidon, 1999; *South Southeast*, London and New York: Phaidon, 2000; *Sanctuary: The Temples of Angkor*, London and New York: Phaidon, 2002; *The Path to Buddha: A Tibetan Pilgrimage*, London and New York: Phaidon, 2003; *Steve McCurry*, London and New York: Phaidon, 2005; *Looking East*, London and New York: Phaidon, 2006; *In the Shadow of Mountains*, New York and London: Phaidon, 2007

42. Shaolin Kung Fu student, Henan province, China, 2004.

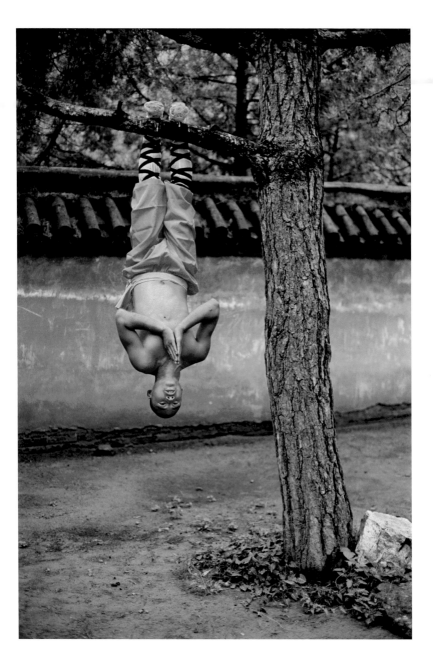

CONSTANTINE MANOS

Born 1934. American. Lives in Boston. Joined Magnum in
1963. Born to Greek immigrant parents in South Carolina,
Constantine Manos began to take photographs at the age
of thirteen. He studied English literature at the University of
South Carolina (1952–55) and at the same time became the
official photographer to the Boston Symphony Orchestra at
the age of just nineteen. After doing his military service in
Europe in the late 1950s, he moved to New York and worked
for *Esquire, Life* and *Look*. In 1961 his first book was published,
Portrait of a Symphony, on the Boston Symphony Orchestra.
From 1961 to 1964 he lived in Greece and worked on his book
A Greek Portfolio, which was published in 1972 and won the
prize for Best Photography Book at the Rencontres d'Arles
festival and at the Leipzig Book Fair; it was reprinted in 1999
to accompany a major exhibition at the Benaki Museum in
Athens. Constantine Manos returned to the US, to Boston,
and worked for Time-Life Books. In 1974, he headed a major
multimedia project, *Where's Boston?*, which was documented
in his book *Bostonians* in 1975. From 1982, he worked on
a large-scale colour project that was turned into the book
American Color, published in 1995, and several exhibitions.
He is currently working on a new edition. Constantine Manos
has been a Magnum Member since 1965 and his photographs
have been selected for major museum collections including
MoMA in New York and the Bibliothèque Nationale in Paris.

Selected books:
Portrait of a Symphony, New York: Basic Books, 1961; *A Greek Portfolio*,
New York: Viking Press, 1972; *Bostonians*, Cambridge, MA: Cambridge
Seven Associates, 1975; *American Color*, New York and London:
W.W Norton, 1995; *Portrait of a Symphony 1960–2000*, Boston: Boston
Symphony Orchestra, 2000

43. Daytona Beach, Florida, USA, 1997.

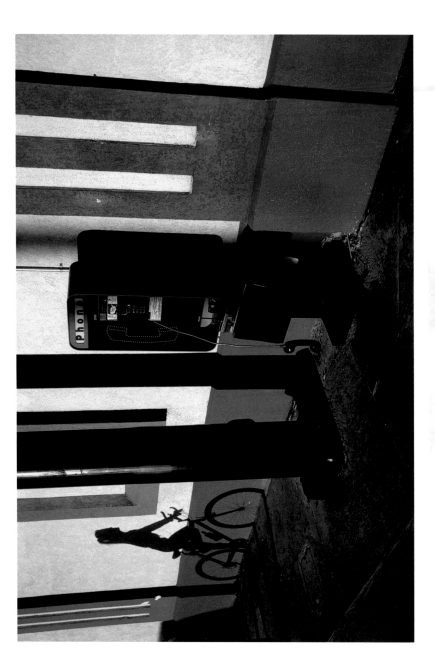

PETER MARLOW

Born 1952. British. Lives in London. Joined Magnum in 1980. After graduating in psychology from the University of Manchester, Peter Marlow spent two years in Latin America (1975–76), before going on to cover international events, including conflict in Lebanon and Northern Ireland, for the Sygma agency between 1976 and 1980. In 1983 he received a grant from the Arts Council of Great Britain and used it to finish his project *London By Night*. In 1988, a grant from the Photographers Gallery in London supported him during a project on the city of Liverpool, then suffering under the economic recession and the policies of Margaret Thatcher. *Liverpool: Looking Out to Sea* was published in 1993. In the early 1990s, Peter Marlow was commissioned by the French département of Somme to photograph the town of Amiens. This was the first time that he worked in medium format (6 x 7), although still in black and white. He then moved on to colour, photographing Japan and the US as well as his home country. Fascinated by architecture and technology, he photographed the final flights of Concorde and its gathered admirers at Heathrow in 2003; these images were published as *Concorde: The Last Summer* in 2006. A Magnum Member since 1986, Peter Marlow has twice been elected President, in 1990 and 2001.

Selected books:
Département Somme, Amiens: Trois Cailloux, 1992; *Liverpool: Looking Out to Sea*, London: Jonathan Cape/Random House, 1993; *Ancient Kumano Roads and Roads to Santiago*, Tokyo: A+A Publishing, 1999; *The Shape of a Pocket*, London: Bloomsbury, 2003; *Concorde: The Last Summer*, London: Thames & Hudson, 2006

44. Liverpool, England, March 1985.

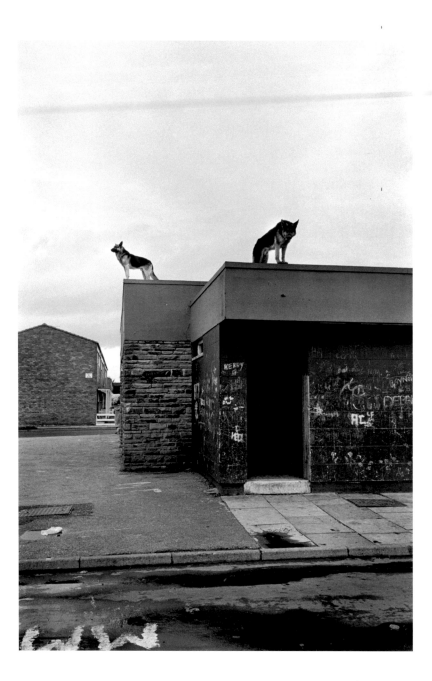

SUSAN MEISELAS

Born 1948. American. Lives in New York. Joined Magnum in 1976. After graduating from Sarah Lawrence College in 1970, Susan Meiselas worked as an assistant to Frederick Wiseman on his documentary film *Basic Training* in 1971. In the same year, she obtained a master's degree in visual education from Harvard and until 1973, worked as a photography advisor at the Community Resources Institute of New York City Public Schools, and published the book *Learn to See* in 1975. In 1972, she began to photograph the lives of strippers at county fairs on the East Coast. This series was published as *Carnival Strippers* in 1976. She covered the civil war in Nicaragua in 1978 and 1979 and her work there won her the Robert Capa Gold Medal in 1979. In 1980 she became a Magnum Member and spent the rest of that decade documenting human rights issues in Latin America. She returned to Nicaragua in 1991 with two directors to film *Pictures from a Revolution*, which traced the lives of the people she had photographed during her first visit to that country. At the same time, she gathered photographs and documents to build up the first visual history of the Kurdish people for a book entitled *Kurdistan: In the Shadow of History*, published in 1997. In 2001, she published *Pandora's Box*, a project on an S&M club in Manhattan; this was followed in 2003 by *Encounters with the Dani*, on one of the indigenous peoples of Indonesia. Among her many awards are the Leica Award for Excellence (1982), the Hasselblad Foundation Photography Prize (1994) and the Cornell Capa Infinity Award (2005). In 1992 she was also awarded the MacArthur Fellowship.

Selected books:

Learn to See, Cambridge, MA: Polaroid Foundation, 1975; *Carnival Strippers*, New York: Farrar, Straus & Giroux, 1976; *Nicaragua, June 1978–July 1979*, New York: Pantheon, 1981; *El Salvador: Work of Thirty Photographers*, New York: Pantheon, 1983; *Chile From Within, 1973–1988*, New York: W.W. Norton, 1990; *Kurdistan: In the Shadow of History*, New York: Random House, 1997; *Pandora's Box*, London: Magnum/ Trebruk, 2001; *Encounters with the Dani*, Göttingen: Steidl; New York: ICP, 2003; *Carnival Strippers*, reprint, Göttingen: Steidl, 2003

45. The Versailles Room, Pandora's Box, New York City, 1995.

WAYNE MILLER

Born 1918. American. Lives in Orinda, California. Joined
Magnum in 1955. Wayne Miller studied finance at the
University of Illinois (1936–40), where he worked as a
photographer for the student newspaper, before going on to
study photography at the Art Center School in Los Angeles
(1941–42). From 1942 to 1946 he served in the US Navy, in
Edward Steichen's Naval Aviation Unit. After the war, he
moved to Chicago and went freelance, working for *Life*,
Fortune, Ladies Home Journal, Ebony and *Collier*. Two
consecutive Guggenheim Fellowships (1946–48) enabled
him to photograph African-American communities in the
northern US. He taught photography at Chicago Institute of
Design and then moved to Orinda, California, and worked
for *Life* magazine until 1953. He assisted Edward Steichen
on the famous exhibition *The Family of Man* at MoMA, New
York (1953–55), which included the work of several Magnum
photographers. A Magnum Member since 1958, he was
President from 1962 to 1966. He developed educational
resources on the environment for the National Park Service
and the Corporation for Public Broadcasting between 1967
and 1971. In 1975, he gave up professional photography to
devote himself to protecting the forests of California. In 1980
he became a Magnum Contributor. In 2000, he published
Chicago's South Side 1946–1948, and these remarkable
images were exhibited the following year at the Visa pour
l'Image festival in Perpignan, France.

Selected books:
A Baby's First Year (with Benjamin Spock), New York: Duell, Sloan and
Pearce, 1955; *The World is Young*, New York: Ridge Press, 1958; *Chicago's
South Side 1946–1948*, Berkeley, CA: University of California Press, 2000

46. Constantin Brancusi in his studio. Paris, France, 1946.

INGE MORATH

1923–2002. Austrian, naturalized American. Joined Magnum in 1953. Born in Austria and brought up in France and Germany, Inge Morath graduated in Romance languages from the University of Berlin in 1944. From 1946 to 1949 she worked as a translator and interpreter for the United States Information Service in Austria, and first began working for Magnum in 1949 as a researcher and assistant to Henri Cartier-Bresson. In 1951 she moved to London and decided to become a photographer, travelling throughout Europe, North Africa and the Middle East. She became a Magnum Member in 1955. It was while photographing on the set of *The Misfits*, starring Marilyn Monroe and Clark Gable, that she first met the playwright Arthur Miller. In 1962 she moved with Miller to New York and Connecticut and lived with him for the rest of his life. Her many travels and her fascination with art led to photo essays that were published in magazines including *Life*, *Paris Match*, *Vogue* and *Holiday*, as well as several books. In 1965 she travelled to the Soviet Union for the first time. Naturalized American from 1966, she made he first trip to China in 1978 and returned there regularly. She was awarded an honorary doctorate from the University of Connecticut in 1984 and received the Austrian Photography Prize in 1992.

Selected books:

Guerre à la Tristesse, Paris: Delpire, 1955; *Fiesta in Pamplona*, London: Photography Magazine, 1956; *From Persia to Iran*, London: Thames & Hudson, 1960; *Le Masque: Drawings by Saul Steinberg*, Paris: Maeght, 1966; *In Russia*, New York: Viking Press, 1969; *Relax and Stretch: The East West Approach to Health*, New York: Simon Walker & Co., 1973; *In the Country*, New York: Viking Press, 1977; *Chinese Encounters*, New York: Farrar, Straus & Giroux, 1979; *Portraits*, New York: Aperture, 1986; *Russian Journal*, New York: Aperture, 1991; *Inge Morath: Fotografien 1952–1992*, Salzburg: Otto Müller, 1992; *Arthur Miller: Photographed by Inge Morath*, Milan: Franco Sciardelli, 1999; *New York*, Salzburg: Otto Müller, 2002; *The Road to Reno*, Göttingen: Steidl, 2006

47. Mrs Eveleigh Nash, London, 1953.

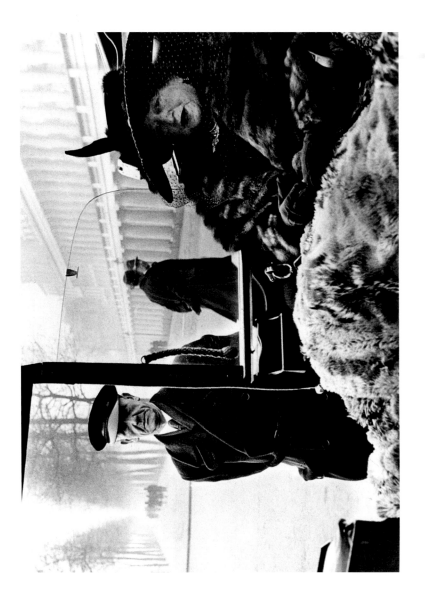

TRENT PARKE

Born 1971. Australian. Lives in Sydney. Joined Magnum in 2002. Trent Parke was born and brought up in Newcastle, in New South Wales. He began to take photographs at the age of twelve, with his mother's Pentax Spotmatic, and developed the pictures himself in the family laundry. He is currently the only Australian photographer represented by Magnum and concentrates mainly on street photography. In 2003, he travelled around Australia with his wife and fellow photographer Narelle Autio, on a 90,000 km journey. The resulting black-and-white series *Minutes to Midnight* was an unflinching portrait of 21st-century Australia which won him the W. Eugene Smith Grant in Humanistic Photography and was exhibited around the world. Since 2006 he has concentrated on urban spaces, in the colour series *Coming Soon*. Trent Parke has won four World Press Photo awards in different categories, and the ABN AMRO Emerging Artist Award in 2006. He became a Magnum Member in 2007.

Selected books:
Dream/Life, Sydney: Hot Chilli Press, 1999; *The Seventh Wave*, Sydney: Hot Chilli Press, 2000; *Minutes to Midnight*, Paris: Filigranes, 2005

48. Summer rain, corner of George and Market Street, Sydney, Australia, 1998.

MARTIN PARR

Born 1952. British. Lives in Bristol. Joined Magnum in 1988.
His childhood interest in photography was encouraged by
his grandfather, who was also a keen photographer. From
1970 to 1973, Martin Parr studied photography at Manchester
Polytechnic. In the 1980s he taught photography, notably at
West Surrey College of Art and Design and at Newport
School of Art. His visual skill and original approach to social
documentary were apparent in his photographs of the
absurdity of mass tourism, as well as the decline of the
working classes. The books *Signs of Times* and *Small World*
in the mid-1990s were hugely successful. In 1994, he became
a Magnum Member after a debate regarding his approach
to the social groups that he documents. In 1999, the book and
exhibition *Common Sense*, on the theme of globalization,
were further successes. In 2002, a major retrospective of his
work was held in London and toured Europe. In 2004 he
was guest artistic director for the Rencontres d'Arles, and
published the first volume of *The Photobook: A History*.
Martin Parr continues to teach and has also expanded
his photographic interests to include fields such as fashion
and advertising.

Selected books:

Bad Weather, London: Zwemmers, 1982; *The Last Resort*, Stockport: Dewi
Lewis, 1986; *The Cost of Living*, Manchester: Cornerhouse, 1989; *Signs of
Times*, Manchester: Cornerhouse, 1992; *Bored Couples*, Paris: Galerie du
Jour, 1992; *Home and Abroad*, London: Jonathan Cape, 1993; *From A to B:
Tales of Modern Motoring*, London: BBC Books, 1994; *Small World*,
Stockport: Dewi Lewis, 1995; *Common Sense*, Stockport: Dewi Lewis,
1999; *Boring Postcards*, London: Phaidon, 1999; *Martin Parr: Autoportrait*,
Stockport: Dewi Lewis, 2000; *Think of England*, London: Phaidon, 2000;
Martin Parr, London: Phaidon, 2002; *The Photobook: A History*, vol. 1,
London: Phaidon, 2005; *The Photobook: A History*, vol. 2, London:
Phaidon, 2007

49. New Brighton, England, 1984.

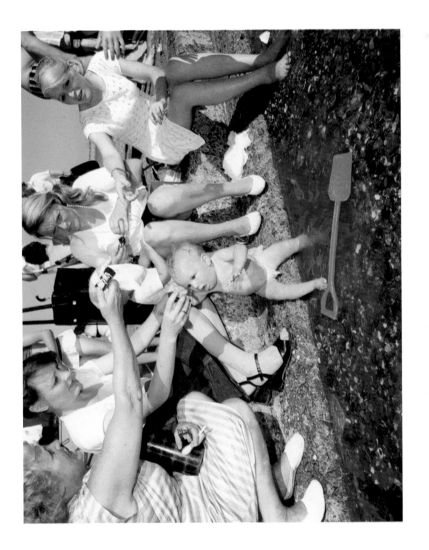

PAOLO PELLEGRIN

Born 1964. Italian. Lives in Rome and New York. Joined
Magnum in 2001. Born in Rome, Paolo Pellegrin began his
career working for the agencies Vu and Grazia Neri. It was
in 1995 that his reportage on the Aids epidemic in Uganda
brought him to prominence, winning a World Press Photo
award and the Kodak Young Photographer Award, Visa
d'Or in Perpignan, France, the following year. This launched
his career as a photojournalist. He published *Cambogia* in
collaboration with Médicins Sans Frontières in 1998, and won
a second World Press Photo award in 2000 for his coverage
of the conflict in Kosovo. Since then, he has covered major
events (the funerals of Yasser Arafat and Pope John Paul II, the
tsunami in Indonesia, Hurricane Katrina) and reported from
many zones of conflict and civil war (Bosnia, Palestine, Iraq,
Afghanistan, Lebanon, Algeria, Sudan, Rwanda). Among the
awards he has received are the Leica Medal of Excellence
(2001), Overseas Press Club Award (2004) and several World
Press Photo Awards (eight in total, including in 2002, 2006 and
2007). He has been a Magnum Member since 2005 and has
been under contract to *Newsweek* since 2000.

Selected books:

Bambini, Rome: Sinnos, 1997; *Cambogia*, Milan: Motta, 1998; *L'au-delà
est là*, Paris: Le Point du Jour Éditeur, 2001; *Kosovo 1999–2000: The Flight
of Reason*, London: Trolley, 2002; *Double Blind*, London: Trolley, 2007;
As I Was Dying, Arles: Actes Sud, 2007

50. The mother of a child killed during the Israeli Defence Forces' incursion
into Jenin, Israel, 2002.

GILLES PERESS

Born 1946. French. Lives in New York. Joined Magnum in 1970.
After studying at the Institute of Political Studies in Paris and
the University of Vincennes, he began to use photography to
create museum installations and books in 1971. Among the
museums and institutions that have exhibited and collected
his work are the Museum of Modern Art, the Metropolitan
Museum of Art, the Whitney Museum of American Art, the
International Center of Photography and PS1, New York;
the Art Institute of Chicago; the Corcoran Gallery of Art,
Washington, DC; George Eastman House in Rochester, NY;
the Walker Art Center and the Minneapolis Institute of Arts;
the V&A in London; the Musée d'Art Moderne, Parc de la
Villette and Centre Pompidou in Paris; the Museum Folkwang,
Essen; the Sprengel Museum, Hanover; and the Nederlands
Foto Instituut. He has been awarded Fellowships from the
Guggenheim, National Endowment for the Arts (1992, 1984,
1979), the Pollock-Krasner Foundation (2002) and New York
State Council of the Arts (2002), and received awards
including the W. Eugene Smith Grant for Humanistic
Photography, the Gahan Fellowship at Harvard University,
the ICP Infinity Award (2002, 1996, 1994), the Erich Salomon
Prize, and the Alfred Eisenstaedt Award (2000, 1999, 1998).
Portfolios of his work have appeared on numerous occasions
in the *New York Times Magazine*, the *Sunday Times
Magazine*, *Du*, *Life*, *Stern*, *GEO*, *Paris Match*, *Parkett*,
Aperture, *Doubletake*, *The New Yorker* and the *Paris Review*.
Gilles Peress became a Magnum Member in 1971, has three
times been Vice-president and twice President. He is now
a Magnum Contributor. He lives in Brooklyn with his wife
Alison Cornyn and their three children.

Selected books:
Telex Iran, Millerton, NY: Aperture, 1984 (reprinted New York: Scalo,
1997); *Farewell to Bosnia*, New York: Scalo, 1994; *The Silence: Rwanda*,
New York: Scalo, 1995; *The Graves: Srebrenica and Vukovar*, New York:
Scalo, 1998; *A Village Destroyed*, Berkeley, CA: University of California
Press, 2002; *Haines: Photo Poche*, Arles: Actes Sud, 2004

51. Victims of cholera, Goma refugee camp, Zaire, 1994.

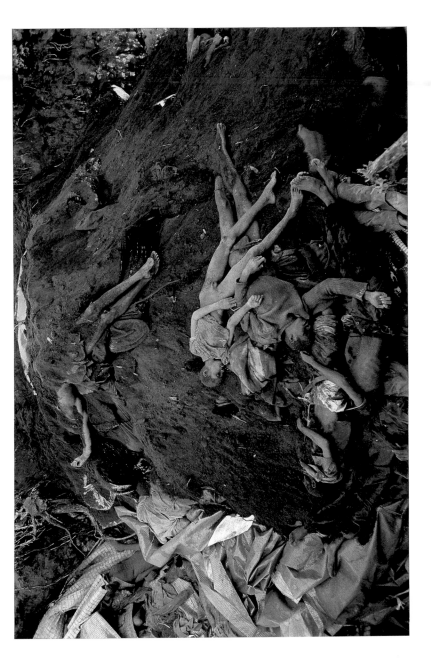

GUEORGUI PINKHASSOV

Born 1952. Russian, naturalized French. Lives in Paris. Joined Magnum in 1988. Gueorgui Pinkhassov became interested in photography began at secondary school. From 1969 to 1971 he studied at the VGIK film institute in Moscow. He then worked for the Mosfilm studios as a cameraman and then as a set photographer. In 1978 he joined the Moscow Union of Graphic Arts and was awarded independent artist status. In the same year, the filmmaker Andrei Tarkovsky invited him to work on the set of the film *Stalker* (1979). In the same year, his work was acclaimed after it featured in a group exhibition of Soviet photography at the Union des Arts Graphiques in Paris. In 1985 he moved permanently to Paris, and worked for the international press, including *GEO*, *Grand Reportage* and the *New York Times Magazine*, but this style of photojournalism did not hold his interest. In his first book, *Sightwalk*, Gueorgui Pinkhassov tried to explore unusual details, exploring the possibilities of light and reflection, and often approaching abstraction. He has been a Magnum Member since 1994.

Selected books:
Sightwalk, London and New York: Phaidon, 1999; *Carnets d'Opéra*, Paris: Xavier Barral, 2003; *Nordmeer*, Hamburg: Mare, 2006

52. Xianjiang, China, 2006.

MARK POWER

Born 1959. British. Lives in Brighton. Joined Magnum in 2002.
After studying painting at Brighton Polytechnic, Mark Power
travelled widely and decided to concentrate entirely on
photography. He worked with various British newspapers and
magazines at the same time as pursuing personal projects,
notably on poverty during the Thatcher years. In 1992, he
began his first major project, photographing sea regions.
Four years later his first book, *The Shipping Forecast*, was
published to great acclaim. From 1997 to 2000 he followed
the building of the Millennium Dome in London, published
as *Superstructure*. From 2000 to 2002, he documented the
restoration of HM Treasury, a listed building from the 19th
century in London's Whitehall: this became *The Treasury
Project*. In 2005, he photographed a series of landscapes on
the very outskirts of London, which was published in 2007
as *26 Different Endings*. Among his most recent projects are
a commission from the European Union Japanese Fest to
photograph the prefecture of Miyazaki in Japan, and another
from Airbus to document the construction of the Airbus A380.
He has also spent several periods in Poland, working on a
project called *The Sound of Two Songs*, due in 2008. His work
has been exhibited in museums and galleries all over the
world. Mark Power is professor of photography at the
University of Brighton and became a Magnum Member
in 2007.

Selected books:
The Shipping Forecast, London: Zelda Cheatle Press, 1996;
Superstructure, London: HarperCollins, 2000; *The Treasury Project*,
Maidstone: Photoworks, 2002; *26 Different Endings*, Brighton:
Photoworks, 2007

53. The funeral of Pope John Paul II, broadcast live from the Vatican.
Warsaw, Poland, April 2005.

RAGHU RAI

Born 1942. Lives in New Delhi. Joined Magnum in 1977.
Raghu Rai became a photographer in 1965 and joined the
New Delhi newspaper *The Statesman* in 1966. He left the
paper in 1976 to go freelance. Impressed by an exhibition of
Rai's work that he had seen in Paris several years previously,
Henri Cartier-Bresson invited him to join Magnum in 1977
as a Correspondent. After working as photo editor for the
magazine *Sunday*, he became director of photography for
India Today magazine in 1982, a post that he held until 1991.
He specializes in only photographing his home land, and has
published more than twenty books, including works on Indira
Gandhi and Mother Teresa. But it was in December 1984,
while reporting from Bhopal in the aftermath of the disaster at
the Union Carbide chemical factory that Raghu Rai took one
of his most famous images, entitled *Burial of an Unknown
Child*. At the behest of Greenpeace he returned to Bhopal in
2002 to document the consequences of this tragedy, which
resulted in 20,000 deaths. Many survivors suffered serious
illness as a result of the leaks of poisonous gas. The book,
Exposure: Portrait of a Corporate Crime, was published in
2004 on the 20th anniversary of the catastrophe and pays
striking testament to the greatest industrial disaster of the
20th century. Raghu Rai has three times been a jury member
for the World Press Photo awards and continues to work for
many major magazines, including *GEO*, *Time*, *The New
Yorker* and *Newsweek*.

Selected books:
A Life in the Day of Indira Gandhi, New Delhi: Nachiketa, 1974; *Delhi:
A Portrait*, Oxford: OUP, 1983; *The Sikhs*, Varanasi: Lustre Press, 1984;
Taj Mahal, Paris: Robert Laffont, 1986; *L'Inde de Raghu Rai*, Paris:
Arthaud, 1988; *Calcutta*, New Delhi: Time Books International, 1989;
Tibet in esilio, Rome: Mondadori, 1990; *Khajuraho*, New Delhi: Time
Books International, 1991; *Raghu Rai's Delhi*, New Delhi: Indus/
HarperCollins, 1994; *Dreams of India*, Singapore: Times Editions, 1996;
My Land and its People, New Delhi: Vadehra Gallery, 1997; *Bhopal Gas
Tragedy*, Chennai: Tulika, 2002; *Exposure: Portrait of a Corporate Crime*,
Amsterdam: Greenpeace, 2002; *Indira Gandhi: A Living Legacy*, New
Delhi: Timeless Books, 2004; *Romance of India*, New Delhi: Timeless
Books, 2005; *Mother Theresa: A Life of Dedication*, New York: Harry N.
Abrams, 2005; *India Notes*, Paris: Intervalles, 2007

54. Flower market, Calcutta, 2004.

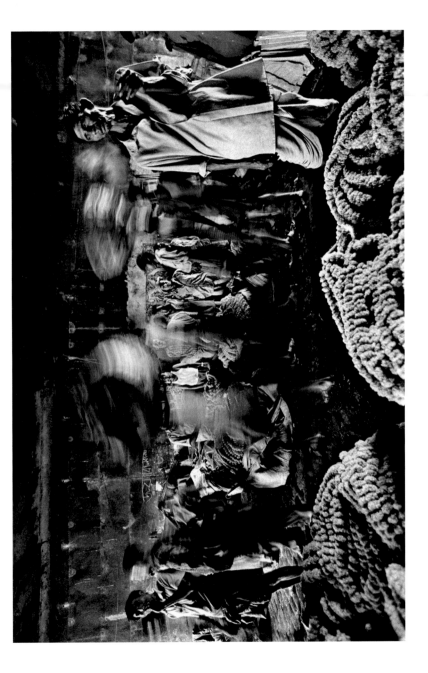

ELI REED

Born 1946. American. Lives in Austin, Texas. Joined Magnum in 1983. A graduate of the Newark School of Fine and Industrial Arts, where he studied pictorial illustration, Eli Reed became a photographer in 1970, encouraged by the artist and photographer Donald Greenhaus. He worked for newspapers in New York, Michigan and California, and travelled to Central America (1982) and Lebanon. His four-month stay in Beirut (1983–84) coincided with bomb attacks on French and US barracks which resulted in more than 300 deaths. He returned to the city in 1987 and produced the book *Beirut: City of Regrets* (1988). He became a Magnum Member in 1988. In the same year he began a project on poverty and its effect on children, which was turned into an NBC documentary made with Scott Fraser: *America's Children: Poorest in the Land of Plenty*. In 1992, he made a documentary on the gangs of Detroit, *Getting Out*, and in 1995 worked with Robert Altman on the movie *Kansas City*. Racism is a notable theme in his work, and is central to his celebrated book *Black in America* (1997). Eli Reed continues to work for many major magazines in the US and teaches photojournalism at the University of Austin, Texas. Among the many honours he has received are the Nieman Fellowship from Harvard University (1982), the Nikon World Understanding Award (1983), the Overseas Press Club Award (1983), the World Press Award and the Leica Medal of Excellence (1988) and the W. Eugene Smith Grant (1992).

Selected books:
Beirut: City of Regrets, New York: W.W. Norton, 1988; *Black in America*, New York: W.W. Norton, 1997; *Local Heroes Changing America*, New York: W.W. Norton, 2000

55. Kakuma refugee camp, Kenya, August 2001.

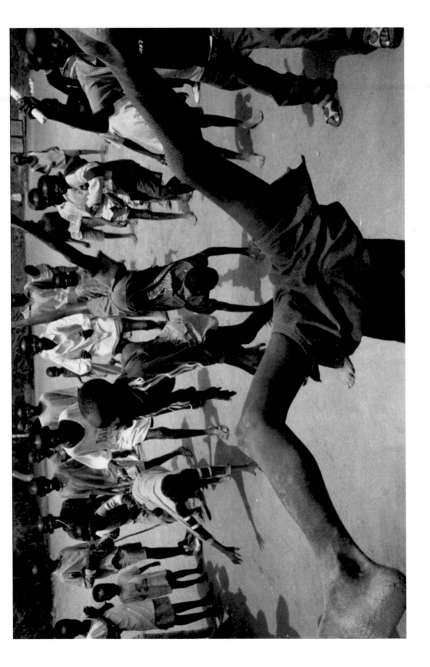

MARC RIBOUD

Born 1923. French. Lives in Paris. Joined Magnum in 1952. Marc Riboud took his first photographs in 1937, at the age of fourteen. During the Second World War, he fought for the Resistance forces in 1943–45. From 1945 to 1948 he studied engineering at the École Centrale in Lyons and worked in a factory, but left in 1951 to pursue photography. In 1952 he was invited to join Magnum by Henri Cartier-Bresson and Robert Capa. In 1955 he became a Magnum Member and travelled by road to India via the Middle East and Afghanistan; he stayed in India for a year and from there, made his first trip to China in 1957. After three months in the Soviet Union in 1960, he covered Algeria becoming independant and travelled in Africa. Between 1968 and 1969 he reported from both South and North Vietnam, where he was one of the first photographers permitted to go. Since the 1980s he has regularly returned to Asia. Marc Riboud has been responsible for some of the most memorable images of the 20th century, such as a young woman holding a flower in front of the bayonets at a Vietnam peace march in Washington DC in 1967, and a man painting the Eiffel Tower. His many books include *Visions of China* and *Capital of Heaven*. He was elected President of Magnum in 1975, and became a Magnum Contributor in 1980.

Selected books:

Women of Japan, London: A. Deutsch, 1959; *Le bon usage du monde*, Lausanne: Rencontre, 1964; *The Three Banners of China*, New York: Macmillan, 1966; *Face of North Vietnam*, New York: Holt, Rinehart & Winston, 1970; *Chine: instantanés de voyages*, Paris: Arthaud, 1980; *Visions of China: Photographs, 1957–1980*, New York: Pantheon, 1981; *Photos choisies, 1953–1985*, Paris: Paris Audiovisuel/Musée d'Art Moderne de la Ville de Paris, 1985; *Journal*, Paris: Denoël, 1986; *Photographs at Home and Abroad*, New York: Harry N. Abrams, 1988; *Capital of Heaven*, New York: Doubleday, 1990; *Marc Riboud: Photofile*, London: Thames & Hudson, 1991; *Angkor, the Serenity of Buddhism*, New York and London: Thames & Hudson, 1993; *Marc Riboud in China: Forty Years of Photography*, New York: Harry N. Abrams; London: Thames & Hudson, 1997; *Istanbul*, Paris: Imprimerie Nationale, 2003; *Marc Riboud*, Paris: Flammarion, 2004

56. Little 'rabbit' in Mandarin Yu's garden, Shanghai, China, 2002.

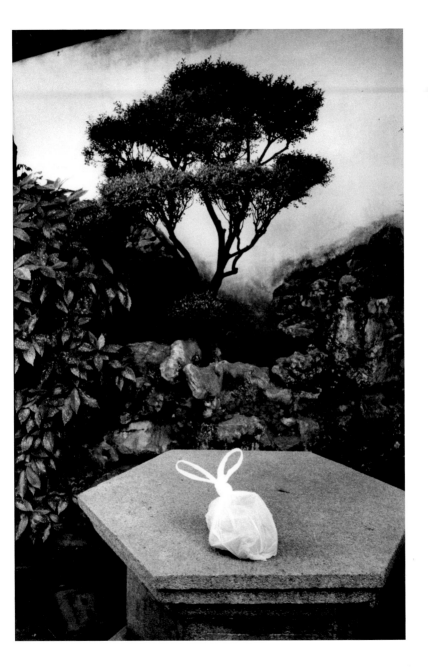

MIGUEL RIO BRANCO

Born 1946. Brazilian. Lives in Rio de Janeiro. Joined Magnum
in 1980. The son of diplomats, Miguel Rio Branco was born
in the Canary Islands, and grew up in Portugal, Brazil,
Switzerland and the US. He began painting and drawing
in 1960, then moved to New York to become a photographer
and experimental filmmaker. In the 1970s he took courses at
the New York Institute of Photography and at the Escola Superior
de Desenho Industrial in Rio de Janeiro. It was in Brazil that
he became a freelance photographer and cinematographer.
He lost all of his black-and-white archives in a fire in 1980 and
from then on worked in colour. The awards he has won for his
photographs and films include the Prix Kodak de la Critique
Photographique (1982) and the International Critics Prize and
Special Jury Prize at the Lille Festival (1982) for his film *Nada*.
He took up painting again in 1985 and in the same year
published his first book, *Dulce Sudor Amargo*, on the Brazilian
town of Salvador do Bahia. His work has gradually moved
towards experimentation with visual poetry and multimedia
installations, as seen in his series *Nakta* (1996), *Gritos surdos*
(2002) and *Plaisir la douleur* (2005), which have been exhibited
around the world. In 2005 his work was shown at the
Rencontres d'Arles festival and at the Maison Européenne
de la Photographie in Paris. His photographs have been
selected for many museum collections. Miguel Rio Branco
has been a Magnum Correspondent since 1980.

Selected books:

Dulce Sudor Amargo, Mexico City: Fondo de Cultura Económica, 1985;
Nakta, Curitiba: Multiprint Gráfica, 1996; *Silent Book*, São Paulo: Cosac &
Naify, 1997; *Miguel Rio Branco*, New York: Aperture, 1998; *Gritos surdos*,
Oporto: Centro Portugues de Fotografia, 2002; *Entre os Olhos, o Deserto*,
São Paulo: Cosac & Naify, 2002; *Plaisir la douleur*, Paris: Textuel, 2005;
Notes on the Tides, Groningen: Groninger Museum, 2006

57. Touch of evil, Nîmes, France, 1994.

GEORGE RODGER

1908–95. British. Lived for a long time in the village of
Smarden, Kent. Founder member of Magnum in 1947.
George Rodger studied at St Bede's College in Manchester
(1921–26) then served in the Merchant Navy. Between 1929
and 1936 he lived in the US, doing various jobs, then returned
to England where he worked as a photographer for the BBC
in London and as a freelancer for the Black Star agency from
1938. He covered the Second World War for *Life* magazine
and in April 1945 he became the first photographer to arrive
at the Bergen-Belsen concentration camp. Traumatized by
the horrors of the war, he began to become increasingly
interested in living close to nature. In 1947 he became a
founding member of Magnum and began a journey across
the continent of Africa, during which he took the photographs
that were published as *Le Village des Noubas* by Robert
Delpire in 1955. Between 1950 and 1980 he visited Africa more
than fifteen times. In 1970 he became a Magnum Contributor.
He returned to Africa three times thanks to a grant from the
Arts Council of Great Britain, in order to photograph the
circumcision ritual of the Masai Moran, which no white
man had ever seen. He died at his home on 24 July 1995.

Selected books:
Red Moon Rising, London: Cresset Press, 1943; *Far on the Ringing Plains*,
New York: Macmillan, 1943; *Desert Journey*, London: Cresset Press, 1944;
Le Village des Noubas, Paris: Delpire, 1955; *George Rodger*, London:
Gordon Fraser, 1975; *World of the Horse*, New York: Octopus/Ridge Press,
1975; *George Rodger, Magnum Opus: Fifty Years in Photojournalism*,
London: Dirk Nishen, 1987; *The Blitz: The Photography of George
Rodger*, London and New York: Penguin, 1990; *Humanity and
Inhumanity: The Photographic Journey of George Rodger*, London:
Phaidon, 1994; *The African Photographs*, London: British Council, 1997;
Photographic Voyager, Petaluma, CA: Barry Singer, 1999

58. Boys of the Gogo tribe wearing circumcision masks. Tanganyika, 1948.

LISE SARFATI

Born 1958. French. Lives in Paris. Joined Magnum in 1997.
Lise Sarfati began to take photographs as a teenager in Nice.
She wrote a dissertation on Russian photography of the 1920s
and received a masters degree from the Sorbonne. In 1986 she
became the official photographer of the Académie des Beaux-
Arts in Paris. In 1989 she went to Russia and spent ten years
studying the country during this period of great transition,
with funding provided by the French Ministry of Culture
and the Villa Médicis. She won the Niépce Prize and the ICP
Infinity Award in 1996 for her Russian work. Her work was
exhibited at the Centre National de la Photographie in Paris
in 1996 and at the Maison Européenne de la Photographie in
2002. *Acta Est* (2000) was her first monograph. After the death
of Marguerite Duras in 1996, Lise Sarfati photographed the
writer's apartment and her house in Neauphle-le-Château,
creating a sort of intimate inventory. Lise Sarfati became a
Magnum Member in 2001. In 2003, she travelled to the US: in
Louisiana, Georgia, Texas, California and Oregon, she took
a series of portraits of teenage girls and boys. This work,
entitled *The New Life*, was published by Twin Palms in 2005.
The New Life was designed to be viewed in sequence, like the
episodes in an endless soap opera in which each character
becomes the raw material for a new subplot that follows its
own course. The series was shown in museums and galleries
internationally. In 2004, Domus Artium in Salamanca and the
Nicolaj Contemporary Art Center in Copenhagen produced
a retrospective exhibition of Sarfati's work and an accompanying
catalogue. In 2005, she went to Lithuania and created a series
for an installation at a group show, commissioned by the
Centre Pompidou, Paris. She is currently working on a
new project in the US.

Selected books:

Acta Est, London: Phaidon, 2000; *Lise Sarfati*, Salamanca: Fundación
Salamanca Ciudad de Cultura, 2004; *The New Life*, Santa Fe, NM:
Twin Palms, 2005

59. Terri, no. 31 from the series *The New Life*. Portland, Oregon, USA, 2003.

FERDINANDO SCIANNA

Born 1943. Italian. Lives in Milan. Joined Magnum in 1982. Ferdinando Scianna began to take photographs in the 1960s while studying literature, philosophy and art history at the University of Palermo (1961–66). In 1962 he met the writer Leonardo Sciascia, with whom he collaborated on a number of projects, including his first book *Feste religiose in Sicilia*, which won the Prix Nadar in 1965. In 1966 he moved to Milan and from 1967 he worked for the weekly magazine *L'Europeo*, first as a photographer and then as a journalist from 1973. In 1974, he become *L'Europeo*'s correspondent in Paris. From 1976, he wrote articles for *Le Monde Diplomatique*, and worked for *La Quinzaine littéraire*. He returned to Milan in 1983 and worked on reportages in Europe, Africa and America. He also built up a reputation as a fashion photographer, with his work appearing in many international magazines. His book *Marpessa* (1993), named after a Dutch model whom he photographed for Dolce & Gabbana, was particularly acclaimed. The diversity of his work is displayed in *Le forme del caos* (1989), which features photographs from throughout his thirty-year career and his thirty or more books. Ferdinando Scianna has been a Magnum Member since 1989.

Selected books:
Feste religiose in Sicilia, Palermo: Leonardo da Vinci Arte, 1965; *I siciliani*, Turin: Einaudi, 1977; *Il grande libro della Sicilia*, Rome: Mondadori, 1984; *L'Istante e la Forma*, Syracuse: Ediprint, 1987; *Ore di Spagna* (with Leonardo Sciascia), Milan: Pungitopo, 1988; *Città del Mondo*, Milan: Bompiani, 1988; *Kami*, Milan: L'Immagine, 1989; *Le forme del caos*, Udine: Art & CRL, 1989; *Leonardo Sciascia*, Milan: Franco Sciardelli, 1989; *Marpessa*, Milan: Leonardo Editore, 1993; *Altrove: reportage di moda*, Milan: Motta, 1995; *Viaggio a Lourdes*, Rome: Mondadori, 1996; *To Sleep, Perchance to Dream*, London: Phaidon, 1997; *Jorge Luis Borges*, Milan: Franco Sciardelli, 1999; *Ignazio Buttitta*, Milan: Franco Sciardelli, 1999; *Altre forme del caos*, Rome: Contrasto, 2000; *Niños del mundo*, A Coruña: Ayuntamiento de A Coruña, 2000; *Sicilia ricordata*, Milan: Rizzoli, 2001; *Obiettivo Ambiguo*, Milan: Rizzoli, 2001; *Quelli di Bagheria*, Rome: Peliti, 2003; *Bibliografia dell'Istante/ Bibliography of the Instant*, Naples: L'Ancora del Mediterraneo, 2003; *Ferdinando Scianna, Fotografie 1963–2006*, Lucca: Fondazione Ragghianti, 2006; *Specchio delle mie brame*, Milan: Galleria Antonia Jannone, 2006

60. Kami health care centre, Bolivia, 1986.

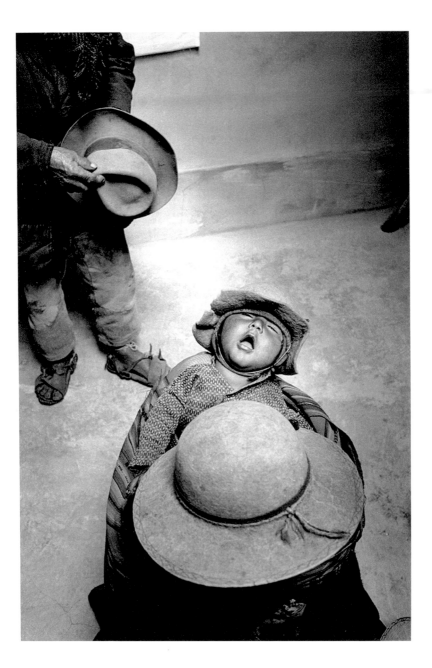

DAVID 'CHIM' SEYMOUR

1911–56. Polish, naturalized American. Founding member
of Magnum in 1947. Born in Warsaw, the son of a family of
Yiddish publishers and printers, David Szymin, as he was
originally known, began as a student of printing in Leipzig
in 1931, then studied chemistry and physics at the Sorbonne
until 1933. He began working regularly for the Parisian press
as a freelance photographer, and it was at this time that he
adopted the nickname Chim. From 1934, his photographs
appeared in *Paris Soir* and *Regards*. Through the Alliance
agency and Maria Eisner, he got to know Henri Cartier-
Bresson and Robert Capa. From 1936 to 1938 he covered the
Spanish Civil War. Then he went to Mexico with a group of
Republican emigrés for *Paris Match*. After the onslaught of
the Second World War and the death of his parents in the Nazi
camps, David Szymin went to New York and became David
Seymour. In 1947, he became a founding member of Magnum.
In 1948, he was commissioned by UNICEF to report on
poverty-stricken children in post-war Europe. Chim's poignant
image of an orphaned girl drawing a picture of her home won
him worldwide regard. In the 1950s, he photographed political
events in Europe as well as the emergence of the state of
Israel. After the death of Robert Capa in 1954, he became the
President of Magnum. David Seymour was killed by machine-
gun fire on 10 November 1956, while covering the Suez Crisis.

Selected books:

Children of Europe, Paris: UNESCO, 1949; *The Vatican: Behind the
Scenes in the Holy City*, New York: Farrar, Straus & Giroux, 1949; *Little
Ones*, Tokyo: Heibonsha, 1957; *David Seymour: 'Chim' 1911–1956*,
New York: Grossman; London: Studio Vista, 1974; *Front populaire* (with
Robert Capa), Paris: Le Chêne, 1976; *Les Grandes photos de la guerre
d'Espagne* (with Robert Capa), Paris: Jannink, 1980; *Chim: The
Photographs of David Seymour*, Boston: Bulfinch Press/Little, Brown,
1996; *Close Enough: Photography by David Seymour*, College Park, MD:
University of Maryland, 1999; *David Seymour: 'Chim'*, Valencia: IVAM,
2003; *David Seymour (Chim)*, London and New York: Phaidon, 2005

61. Bernard Berenson, Borghese Gallery, Rome, Italy, 1955.

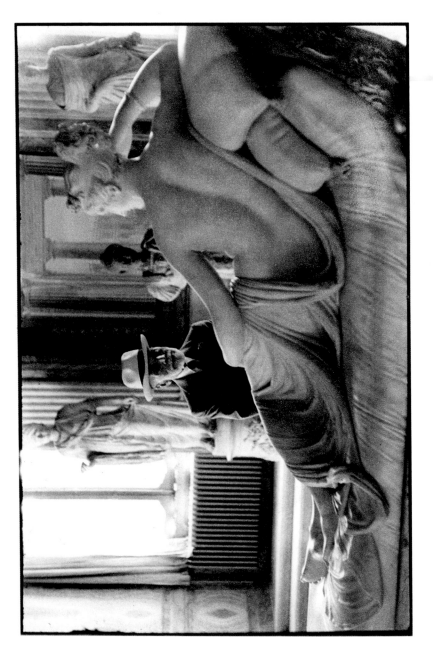

MARILYN SILVERSTONE

1929–99. American. Joined Magnum in 1964. Born in London
to American parents, Marilyn Silverstone emigrated to the
US before the start of the Second World War. It was Eli Marcus,
a Jewish-German photographer who fled the Nazi regime in
1941 that encouraged her to take up photography. In 1955,
Marilyn Silverstone became a freelance photographer and
began to travel to Africa, Central America, the Soviet Union,
Poland, Yugoslavia and more. She was represented by the
Nancy Palmer/Gamma agency. In 1959, she moved to New
Delhi, where she witnessed the arrival of the exiled Dalai
Lama. Commissioned by *Life* magazine, she was the only
female photojournalist to follow his flight to India. Following
Nehru's funeral, she met Marc Riboud who was impressed
by her vivacity and energy and showed her work to Henri
Cartier-Bresson. She became a Magnum Member in 1967,
then a Contributor in 1975. She converted to Tibetan
Buddhism and was ordained as a nun in 1977. She helped
to found the Shechen monastery, near Bodhnath in Nepal,
where she died on 28 September 1999.

Selected books:

Bala, Child of India, London: Methuen, 1962; *Gurkhas and Ghosts:
The Story of a Boy in Nepal*, London: Methuen, 1964; *Ocean of Life:
Visions of India and the Himalayan Kingdoms*, New York: Aperture, 1985;
The Black Hat Dances: Two Buddhist Boys in the Himalayas, New York:
Dodd, Mead & Co., 1987

62. The Dalai Lama at the opening of the Tibet House. Delhi, India, 1965.

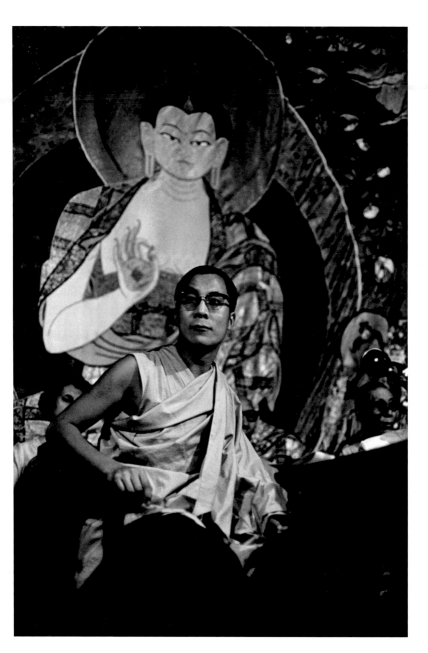

W. EUGENE SMITH

1918–78. American. Joined Magnum in 1955. William Eugene Smith took his first photographs at the age of fifteen, and soon afterwards began to sell his work to local newspapers in his home state of Kansas. After studying at the New York Institute of Photography, he worked for *Newsweek* in 1937 and left a year later. Represented by the agency Black Star, he worked for *Life*, *Collier* and *Parade*. He covered the Second World War in the South Pacific, first for the magazine *Flying* and then for *Life* and *Parade*. He was seriously wounded in a bombing raid and spent two years convalescing. From 1947 to 1954 he worked for *Life* once again and produced some exceptional photo essays: *Country Doctor*, *Nurse Midwife*, *Spanish Village*, and *Albert Schweizer: A Man of Mercy*. He joined Magnum in 1955. A publisher asked him to photograph the city of Pittsburgh; he was meant to stay for a month but spent two years there, and a further eighteen months selecting from some 13,000 photographs. This series was finally published in 2001. He became a Magnum Member in 1957 but resigned in 1959, remaining a Contributor. In 1971 he settled in Minimata, Japan, with his wife, to document the consequences of industrial pollution. On returning to the US, he taught at the University of Arizona in Tucson. He died of a stroke in 1978. The W. Eugene Smith Memorial Fund to promote humanistic photography was founded in 1980.

Selected books:

Japan: A Chapter of Image, Tokyo: Hitachi, 1963; *W. Eugene Smith: His Photographs and Notes*, New York: Aperture, 1969; *Minamata*, Tucson, AZ: Holt, Rinehart & Winston, 1975; *W Eugene Smith, Master of the Photographic Essay*, New York: Aperture, 1981; *W. Eugene Smith: Photo Poche*, Paris: CNP, 1983; *Let Truth Be the Prejudice*, New York: Aperture, 1985; *W. Eugene Smith*, New York: Pantheon, 1986; *Shadow and Substance*, New York: McGraw-Hill, 1989; *W. Eugene Smith: Photofile*, London: Thames & Hudson, 1990; *W. Eugene Smith: Photographs 1934–1975*, New York: Harry N. Abrams, 1998; *Du côté de l'ombre*, Paris: Le Seuil, 1998; *W. Eugene Smith: Aperture Masters of Photography*, New York: Aperture, 1999; *Dream Street: W. Eugene Smith's Pittsburgh Photographs*, New York: W.W. Norton, 2001

63. Fishermen, Minamata Bay, Japan, 1971.

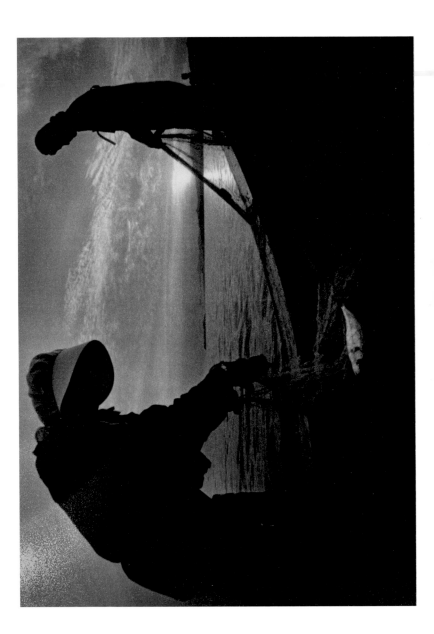

ALEC SOTH

Born 1969. American. Lives in Minneapolis, Minnesota. Joined Magnum in 2004. It was in 2004, with his first series *Sleeping by the Mississippi*, shot over several visits to the shores of the famous river, that Alec Soth first came to public attention. His exhibition at the Whitney Museum in New York and the accompanying book were acclaimed by US critics. His large-format colour pictures present, in a descriptive style, landscapes, interiors, portraits, objects and personal memories. His work continued in another symbolic location: Niagara Falls, producing a complex series of images including couples and love letters. Since 2005, Alec Soth has been represented by the prestigious Gagosian Gallery in New York, and his photographs feature in the collections of many major museums, including MoMA in San Francisco, the Museum of Fine Arts in Houston and the Walker Art Center in Minneapolis. He works regularly with the *New York Times Magazine*, *GQ*, *Newsweek*, and *The New Yorker*. Alec Soth has received several awards, including the Jerome Travel and Study Grant and the McKnight Photography Fellowship. He became a Magnum Associate in 2006.

Selected books:
Sleeping by the Mississippi, Göttingen: Steidl, 2004; *Niagara*, Göttingen: Steidl, 2006

64. Two towels, Canada, 2004.

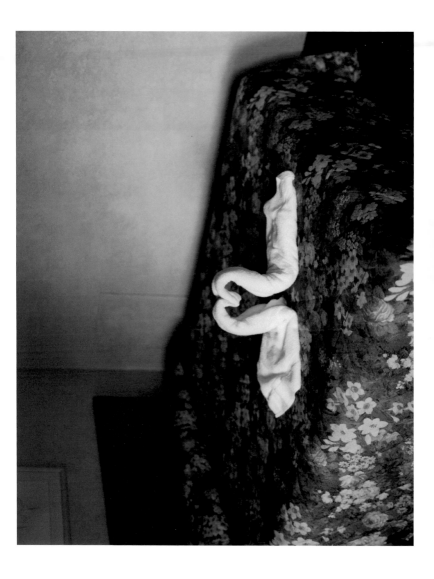

CHRIS STEELE-PERKINS

Born 1947. British. Lives in London. Joined Magnum in 1979. Born in Burma, Chris Steele-Perkins grew up in England and studied chemistry at the University of York and psychology at Newcastle University. After graduating in 1970, he moved to London in 1971 and became a freelance photographer, beginning his first overseas project in Bangladesh in 1973 and teaching photography part-time. In 1975 he joined the collective EXIT, who dealt mainly with social issues in British cities, and together with Mark Edwards he organized exhibitions at the Photographers' Gallery in London (1975, 1977). He joined the Viva agency in 1976, followed by Magnum in 1979, and reported from locations in the developing world, including Central America and Africa, as well as Lebanon. In 1979 he published his first book, *The Teds*, on the young working-class men influenced by the Teddy Boy culture of the 1950s. Ten years later, *The Pleasure Principle* built up a portrait of Britain in the 1980s. He then covered the situation in Afghanistan, visiting that country four times during the 1990s and publishing *Afghanistan* in 2000. Since then, he has worked most notably in Japan, as documented in the books *Fuji* (2001) and *Tokyo Love Hello* (2007). Chris Steele-Perkins has won many awards, including the Tom Hopkinson Prize for British Photojournalism (1988), the Oskar Barnack Prize (1988), the Robert Capa Gold Medal (1989), and a World Press Photo Award (2000). A Magnum Member since 1983, he was President from 1995 to 1998.

Selected books:

The Teds, London: Travelling Light, 1979; *About 70 Photographs*, London: Arts Council of Great Britain, 1980; *La Grèce au présent*, Paris: Centre Georges-Pompidou, 1981; *Survival Programmes: In Britain's Inner Cities*, Maidenhead: Open University Press, 1982; *Beirut: Frontline Story*, London: Pluto, 1983; *The Pleasure Principle*, Manchester: Cornerhouse, 1989; *St Thomas' Hospital*, London: St Thomas' Hospital, 1992; *Afghanistan*, London: Westzone, 2001; *Fuji*, New York: Umbrage, 2001; *Echoes*, London: Trolley, 2003; *Tokyo Love Hello*, Paris: Intervalles, 2007; *Northern Exposures*, Newcastle upon Tyne: Northumbria University Press, 2007

65. Prison inmates in a punishment cell. Leningrad (St Petersburg), Russia, 1988.

DENNIS STOCK

Born 1928. American. Lives in Woodstock, NY. Joined Magnum
in 1951. Apprentice to the photographer Gjon Mili from 1947
to 1951, Dennis Stock won first prize in *Life* magazine's Young
Photographers Contest. In 1955 he photographed the promising
young movie star James Dean, with the intention of building
up a visual biography; this was later published as a book.
From 1957 to 1960, Dennis Stock took a series of intimate
portraits of jazz and blues musicians, including Billie Holiday,
Sydney Bechet and Duke Ellington; these won him first prize
in the International Photography Competition in Poland and
were published in the book *Jazz Street* (1960). In the 1960s,
he worked predominantly on three projects: *California Trip*,
The Alternative, on the counterculture of the sixties, and
Road People. In the 1970s and 1980s, Dennis Stock lived and
worked in Provence, France, and published books of colour
images that celebrated the beauty and magic of nature,
including *Provence Memories* and *Flower Show*. In the 1990s,
he returned to his urban origins, exploring modern city
architecture. He won an Advertising Photographers of
America award in 1991. He has been a Magnum Member
since 1957.

Selected books:

Portrait of a Young Man: James Dean, Tokyo: Kadokawa Shoten, 1956;
Jazz Street, Garden City, NY: Doubleday; London: André Deutsch, 1960;
California Trip, New York: Grossman, 1970; *The Alternative: Communal
Life in New America*, New York: Collier; London: Collier-Macmillan,
1970; *Living Our Future: Francis of Assisi and the Church Tomorrow*,
Chicago: Franciscan Herald Press, 1972; *Edge of Life: World of the
Estuary*, San Francisco: Sierra Club Books, 1972; *Brother Sun*, San
Francisco: Sierra Club Books, 1974; *California: The Golden Coast*, New
York: Viking Press, 1974; *A Haiku Journey*, Tokyo: Kodansha, 1974; *Alaska*,
New York: Harry N. Abrams, 1979; *America Seen*, Paris: Contrejour, 1980;
Flower Show, New York: Rizzoli, 1986; *Provence Memories*, Boston: Little,
Brown, 1988; *New England Memories*, Boston: Little, Brown, 1989; *Made
in USA*, Ostfildern: Cantz, 1995; *James Dean: Fifty Years Ago*, New York:
Harry N. Abrams, 2005

66. Tulip series, 2001.

LARRY TOWELL

Born 1953. Canadian. Lives in Ontario. Joined Magnum in 1988. Larry Towell studied visual arts at York University in Toronto from 1972 to 1976. He then left to do voluntary work in Calcutta, where he began to write and take photographs. On his return to Canada, he devoted himself to poetry and teaching folk music. In 1984 he became a freelance photographer and writer, with an interest in exiles and the dispossessed, as well as peasant rebellion. In 1988 his second book of poetry was published, followed in 1990 by a book on the Nicaraguan Contra War and in 1992 by a book of poems and photographs about the Vietnam War. Two years later, he finished a book of photographs and interviews on the disappeared in Guatemala. In 1996 he finished a ten-year project on El Salvador and then began further projects on the Palestinians (1999 and 2005). He is primarily interested in the human condition, in the way in which people in all circumstances manage to overcome obstacles. His facination with exiles led him to photograph Mennonite communities in Canada, Mexico and Bolivia. He is currently finishing a project on his own family, based at his farm in Ontario. Larry Towell's reportage photography has been widely acclaimed in recent years, winning him awards that include the W. Eugene Smith Award (1991), several World Press Photo Awards (including Photo of the Year in 1994), the Hasselblad Foundation Prize (1999), the Henri Cartier-Bresson Prize (2003) and the Prix Nadar (2005). He lives with his wife and four children on a 75-acre farm in Ontario. He has been a Magnum Member since 1993.

Selected books:
Burning Cadillacs, Windsor, Ontario: Black Moss Press, 1983; *Gifts of War*, Toronto: Coach House Press, 1988; *Somoza's Last Stand: Testimonies from Nicaragua*, Trenton, NJ: Williams Wallace Publishers, 1990; *The Prison Poems of Ho Chi Minh*, Dunvegan, Ontario: Cormorant Books, 1992; *House on Ninth Street: Interviews and Photographs from Guatemala*, Dunvegan, Ontario: Cormorant Books, 1994; *El Salvador*, New York: W.W. Norton, 1997; *Then Palestine*, New York: Aperture, 1998; *The Mennonites*, London: Phaidon, 2000; *No Man's Land*, Paris: Textuel, 2005; *In the Wake of Katrina*, London: Chris Boot, 2006; *The World From My Front Porch*, London: Chris Boot, 2008

67. San José las Flores, Chalatenango, El Salvador, 1991.

ILKKA UIMONEN

Born 1966. Finnish. Lives in New York. Joined Magnum in 2002.
Ilkka Uimonen grew up in the small town of Rovaniemi, close
to the Arctic Circle. After studying in Finland, he decided
to travel through Europe, the US and Asia. His career as a
photojournalist began at the age of twenty-five when he
found a camera in a pub in London, where he was working
at the time. He became a freelancer and worked for Dutch
newspapers after settling for a while in the Netherlands.
He went on to attend workshops at the ICP in New York and
worked for the New York offices of Sygma. He covered several
wars, including the conflict in the former Yugoslavia in 1999
and in Afghanistan in 2001. He has also made several visits
to Israel and the Palestinian territories, particularly after
the Second Intifada. His images of the Middle East were
published in the book *Cycles* in 2004. He was also in Iraq
in 2003 when the US invasion took place. His photographs
have been widely published by *Newsweek*, *Time*, *People*
and *National Geographic*. Ilkka Uimonen became a Magnum
Associate in 2005.

Selected books:
Cycles, London: Trolley, 2004

68. Second Intifada, Israel, 2000.

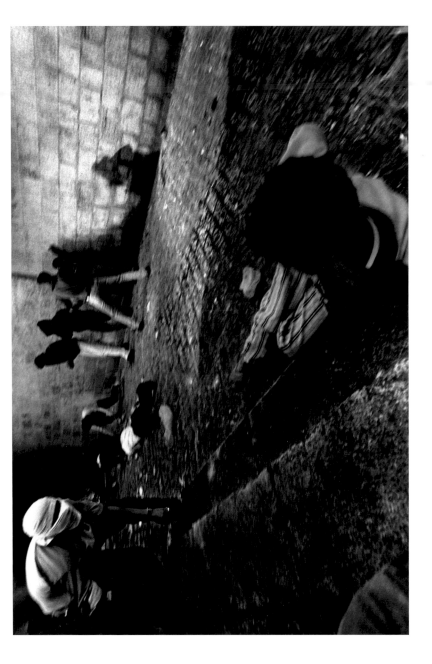

JOHN VINK

Born 1948. Belgian. Lives in Phnom Penh. Joined Magnum in 1993. John Vink became a freelance photographer in 1971, after studying photography at the La Cambre school in Brussels. A founder member of the Vu agency in 1986, he received the W. Eugene Smith Grant in the same year and used it to complete a project begun in 1985 on water management in the Sahel region of Africa. John Vink also distinguished himself with long-term projects on Italy (1984–88) and in particular on refugees throughout the world (1987–94). This series, created over several trips to Central America, Asia and Africa, became the subject of the book *Réfugiés* and of a major exhibition at the Centre National de la Photographie in Paris. A Magnum Member since 1997, John Vink made regular visits to the Indochina peninsula, especially to Cambodia where he is now based. The book *Peuples d'en haut* was published in 2004 and brings together a series begun in the mid-1990s on high-altitude communities in Laos, Guatemala and Georgia, who have been shielded from globalization.

Selected books:
Réfugiés: photographies de John Vink, 1987–1994, Paris: CNP, 1994; *J'ai deux amours: Portraits d'exil*, Paris: Le Cherche Midi Éditeur, 1998; *Avoir 20 ans à Phnom Penh*, Paris: Alternatives, 2000; *Peuples d'en haut: Laos, Guatemala, Géorgie*, Paris: Autrement, 2004; *Poids mouche*, Phnom Penh: Éditions du Mekong, 2006

69. Bac Ninh, Vietnam, 1990.

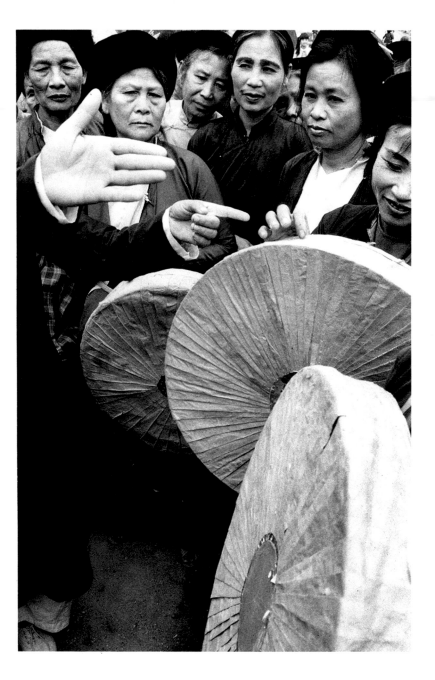

ALEX WEBB

Born 1952. American. Lives in New York. Joined Magnum in 1974. After studying literature and history at Harvard (1970–74) and photography at Harvard's Carpenter Center for the Visual Arts, in 1972 Alex Webb attended the Apeiron photography course run by Bruce Davidson and Charles Harbutt (a Magnum member from 1964 to 1981). In 1974, Webb began his career as a photographer, and his work went on to be published in the *New York Times Magazine*, *GEO* and *Stern*, and later in *Life* and *National Geographic*. He developed an interest in the Caribbean and Latin America, creating an aesthetic that united traditional photojournalism with street photography, while exploring the subtle use of colour. This work led to the publication of *Hot Light / Half-Made Worlds: Photographs from the Tropics* in 1986. After *Crossings* in 2001, the fruit of twenty-six years of work on the tensions of the US–Mexico border, he published *Istanbul* in 2007, an exploration of the complexities of the Turkish city. Alex Webb has won several awards, including the Guggenheim Foundation Fellowship, the Leica Medal of Excellence and the David Octavius Hill Award. His work has been exhibited at many museums and institutions both in the US and in Europe. He has been a Magnum Member since 1979.

Selected books:

Hot Light / Half-Made Worlds: Photographs from the Tropics, London: Thames & Hudson, 1986; *Under a Grudging Sun: Photographs From Haiti Libéré*, London: Thames & Hudson, 1989; *From the Sunshine State: Photographs from Florida*, New York: Monacelli Press, 1996; *Amazon: From the Floodplains to the Clouds*, New York: Monacelli Press, 1997; *Dislocations*, Cambridge, MA: Harvard University Press, 1998; *Crossings: Photographs from the US–Mexico Border*, New York: Monacelli Press, 2001; *Alex Webb habla con Max Kozloff*, Madrid: La Fábrica, 2003; *Istanbul: City of a Hundred Names*, New York: Aperture, 2007

70. View from a barbershop near Taksim Square, Istanbul, Turkey, 2001.

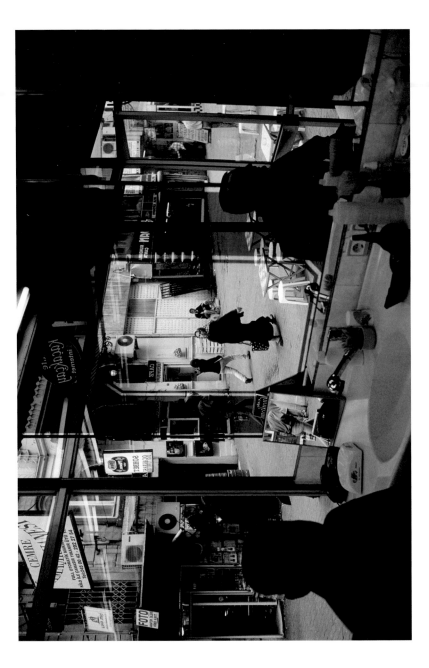

DONOVAN WYLIE

Born 1971. Northern Irish. Lives in London. Joined Magnum in 1992. Donovan Wylie was born in Belfast, and took his first photographs at the age of ten. At the age of fifteen he left school and at seventeen he spent three months travelling across Ireland. He was still very young when his photographs were first published in the book *32 Counties*. A major part of his work, often described as 'archaeological', is rooted in the social and political landscape of Northern Ireland. In 2003, he photographed the Maze prison just after its closure, and the resulting book was internationally acclaimed. His work for newspapers and magazines includes *The Telegraph*, *Stern* and *The New York Times Magazine*; his photographs have also been widely exhibited and feature in the permanent collections of museums such as the Centre Pompidou in Paris and the V&A in London. In parallel to his photography career, Donovan Wylie has made several documentary films, winning a Best New Director award in 2001 for his Channel 4 film *The Train*, on the Russian Orthodox church. He recently finished a photographic project on the Irish border. Donovan Wylie has been a Magnum Member since 1997.

Selected books:
32 Counties, London: Secker & Warburg, 1989; *The Dispossessed*, London: Picador, 1992; *Notes from Moscow*, London: Trans-Atlantic Publications, 1994; *Ireland: Singular Images*, London: André Deutsch, 1994; *Losing Ground*, London: Fourth Estate, 1998, *The Maze*, London: Granta Books, 2004; *British Watchtowers*, Göttingen: Steidl, 2007

71. The Maze Prison. Chapel, Phase 3. Northern Ireland, 2003.

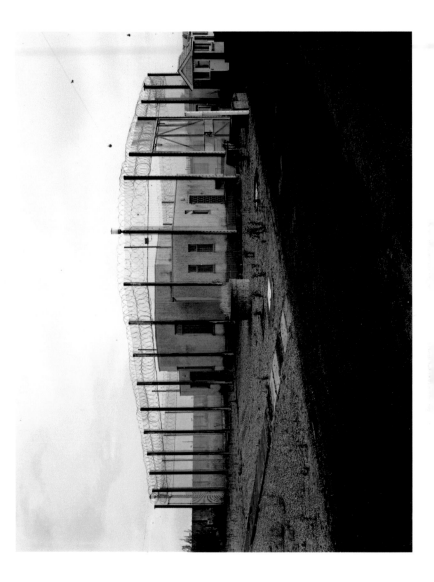

PATRICK ZACHMANN

Born 1955. French. Lives in Paris. Joined Magnum in 1985.
A freelance photographer since 1976, he has covered
many stories for the press in France and overseas. In 1982 he
produced a reportage on the Naples Mafia which became a
touring exhibition and a book, *Madonna!* (1983). Between 1982
and 1984, while working on a project on the French Ministry
of Culture's 'motorway landscapes' scheme, he also
photographed the northern districts of Marseilles and the lives
of young immigrants. He also spent seven years working on
a personal essay on Jewish identity in France, which became
his second book, *Enquête d'identité*, in 1987. In 1989, his report
on the student uprising in Beijing was seen all over the world.
In 1995, a project he had been working on since 1986 on the
Chinese diaspora throughout the world was published in
book form as *W. ou l'oeil d'un long-nez*, and was also turned
into an exhibition that toured ten Asian countries as well as
Europe. In 1997, he exhibited a series of photographs of
Malian immigrants in France, accompanied by a video film
of the return of one immigrant to his village in Mali. The book
Maliens, ici et là-bas was published at this time. After making
several documentaries, he went to Chile to photograph the
country after the Pinochet dictatorship. For many years, he
has had a special interest in cities by night. He was Vice-
president of Magnum Paris in 1996 and 1997. Patrick
Zachmann's awards include the Prix Médicis 'Hors Les Murs'
in 1986, the Niépce Prize in 1989, as well as the Art Directors
Club Merit Award in 1992. He has been a Magnum Member
since 1990.

Selected books:
Madonna!, Paris: Éd. de l'Étoile/Cahiers du Cinéma, 1983; *Enquête
d'identité: Un juif à la recherche de sa mémoire*, Paris: Contrejour, 1987;
20 ans de rêves, Paris: Syria Editions, 1993; *W. ou l'oeil d'un long-nez*,
Paris: Marval, 1995; *Maliens ici et là-bas*, Paris: Plume, 1997; *Chili: Les
routes de la mémoire*, Paris: Marval, 2002

72. A girl from the school of drama mimes the suffering of the Chinese people.
Tiananmen Square, Beijing, China, 1989.

IN UNIVERSAL TIME

Photography has changed. Democratization has gone hand in hand with banalization. Nonetheless, helped by the rising number of amateur photographers, its audience is increasing and before our eyes interest is rising in the work of photographers both past and present, of those who simply realized one day that they would become photographers and those who deliberately chose this as a path.

'Hey Bob, Henri, Chim, George! You see we are still around... Thank you for making it possible...'

In this message of 17 April 2007, marking the anniversary of the creation of Magnum Photos, Abbas was thanking in his own way the founders of the cooperative. Without wishing to fall into sentimentality, we should note that sixty years later, with its rich and diverse group of members, Magnum Photos is still the exclusive property of its photographers and they still independently pursue the course laid down by those four legendary men.

When it created the agency rules and especially when it set out the long integration process for future members, the collective found the key to its survival: the primacy of the photographic body of work, of the gaze of the artist over the contingencies of the marketplace. Over sixty years, this initial course has never changed. It allows a Nominee to become an Associate and then a full Member within four to eight years. Deliberations over memberships and the status of the candidates take place once a year behind closed doors, between photographers. It is this process that forms the symbolic founding act of the group. The required period of observation allows the agency to confirm that the candidate is not a one-trick pony but someone with a substantial body of work. Candidates need to demonstrate their commitment, their inner strength, their capacity to continue on the same path, to let their distinctiveness survive and thrive.

This ritual is striking in its modernity, for sixty years later, despite its apparent harshness, it allows Magnum to embrace a wide cross-section of documentary photography.

Magnum Photos has always represented a gamut of different approaches and photographic visions. Over time, the iconic figures have become part of the collective unconscious and have sometimes masked this richness. The changing times have also highlighted genres. Today the photographer's artistic approach is accepted, understood, even demanded. It is through this prism that reality becomes palpable.

But beyond the categories, beyond their diversity, the photographers of Magnum Photos share the same concern for the world. Whether they espouse pseudo-objectivity or a disquieting subjectivity, in which emotion wins out over simply witnessing, whether they embark on long-term photographic projects or capture images in a decisive moment, they show us the world, their own world, with its highs and its lows, the world in universal time.

Julien Frydman
Bureau Chief, Magnum Paris

CHRONOLOGY

1947 First meeting takes place on 17 April in the restaurant at the Museum of Modern Art, New York. The founding members are Robert Capa, Henri Cartier-Bresson, George Rodger, David 'Chim' Seymour, and William Vandivert. Maria Eisner is named treasurer and secretary. Rita Vandivert is elected president. The first offices are located at 21 East 10th Street, New York, and 22 Rue de Pontoise, Paris. Magnum Photos, Inc. is officially created on 22 May. Commissioned by the *New York Herald Tribune* and *Ladies' Home Journal*, Robert Capa and John Steinbeck spend more than three months in the Soviet Union.

1948 William and Rita Vandivert resign. Henri Cartier-Bresson photographs Mahatma Gandhi at his home, Birla House in Delhi, several hours before the great Indian spiritual leader is assassinated by a Hindu fundamentalist. Publication in *Ladies' Home Journal*, between May 1948 and April 1949, of *People Are People the World Over*, a series of reportages on the lives of farming families in different countries. Capa, Rodger and Seymour represent Magnum and it is the first major collective commission.

1949 Werner Bischof becomes a member. The exhibition *Magnum Reports the World* is shown at the Photo League Gallery, New York. UNESCO publishes *Children of Europe*, bringing together images of child victims of the Second War War, taken by David Seymour in Austria, Greece, Italy, Hungary and Poland after the war.

1950 Ernst Haas becomes a member.

1951 Robert Capa becomes president. *Life* publishes the first instalment in the Indian trilogy by Werner Bischof, 'Famine in Bihar'. 'Youth and the World', known by the codename Generation X, brings together portraits of 23 young people from 14 countries, all twenty years old. This is Magnum's second group commission for *Ladies' Home Journal*.

1952 Tériade publishes Henri Cartier-Bresson's *Images à la sauvette*, with a cover by Henri Matisse. The introduction features a quote by Cardinal de Retz: 'There is nothing in the world that does not have its decisive moment.' This inspires the title of the English-language edition: *The Decisive Moment*.

1953 John G. Morris becomes international editor in chief. *Life* magazine lauds Ernst Haas as one of the agency's first colour photographers, by publishing *Images from a Magic City*.

1954 16 May: Werner Bischof dies in the Peruvian Andes.
25 May: Robert Capa dies near Thai-Binh in Indochina.
Cornell Capa, Elliott Erwitt, Burt Glinn, Erich Hartmann and Kryn Taconis become members. David Seymour becomes president, following the death of Robert Capa.

1955 The first rules in Magnum's new photographer's charter come into effect. Erich Lessing, Inge Morath and Marc Riboud become members. *Family of Man*, the major exhibition at MoMA, New York, organized by Edward Steichen (assisted by Wayne Miller) features many contributions from Magnum photographers: Ernst Haas, Robert Capa, Werner Bischof, Henri Cartier-Bresson, Elliott Erwitt, George Rodger, Eve Arnold, David Seymour and Burt Glinn.

1956 10 November: David Seymour is killed by machine-gun fire while reporting on the Suez Crisis. Ansel Adams, Philippe Halsman, Dorothea Lange, Russell Lee, Herbert List and Wayne Miller constitute the first official group of Magnum correspondents, although some of them have collaborated with the agency since 1948. They are designated as 'independent

photographers with a relationship to Magnum', who have chosen Magnum as 'their exclusive agent, although they work directly with some clients'. Cornell Capa becomes president.

1957 Eve Arnold, Brian Brake, W. Eugene Smith and Dennis Stock become members. Kryn Taconis reports on the Algerian liberation movement. Magnum Paris blocks publication for fear of reprisals.

1958 Wayne Miller becomes a member.

1959 René Burri and Bruce Davidson become members. W. Eugene Smith resigns.

1960 Kryn Taconis resigns. Ernst Haas becomes president. Eve Arnold, Cornell Capa, Henri Cartier-Bresson, Bruce Davidson, Elliott Erwitt, Erich Hartmann, Ernst Haas, Inge Morath and Dennis Stock take turns photographing the set of *The Misfits*, the film directed by John Huston and starring Marilyn Monroe, Clark Gable and Montgomery Clift. The exhibition *The World as Seen by Magnum Photographers*, curated by Ernst Haas, opens at the Smithsonian Institute in Washington DC, then goes to Europe and Japan.

1961 Sergio Larrain becomes a member. Elliott Erwitt becomes president. Cornell Capa decides that Magnum should cover the first 100 days of John F. Kennedy's presidency. *Let Us Begin: The First 100 Days of the Kennedy Administration* is the result.

1962 Wayne Miller becomes president.

1963 The collective work *Peace on Earth: Photographs by Magnum* is published, prefaced by Pope John XXIII's 'Pacem in Terris' encyclical.

1964 Charles Harbutt becomes a member. Magnum Films is created as a special department for the making and distribution of films.

1965 Constantine Manos becomes a member.

1966 Danny Lyon becomes a member. Henri Cartier-Bresson and Ernst Haas become contributors. Brian Brake resigns. Elliott Erwitt becomes president again.

1967 Ian Berry, David Hurn, Marilyn Silverstone and Burk Uzzle become members. Charles Harbutt, Cornell Capa, Micha Bar-Am and Leonard Freed cover the Six-Days War in June, in which Israel opposed a coalition formed by Egypt, Syria and Jordan.

1968 Bruno Barbey and Don McCullin become members. Danny Lyon resigns. Constantine Manos covers the funeral of civil rights leader Martin Luther King. Bruno Barbey photographs the student uprising in Paris's Latin Quarter and the strikes that paralyse France in the spring. Danny Lyon publishes *Bikeriders*, a book on a Chicago motorcycle gang. *Typically American* is Burk Uzzle's first solo exhibition, and takes place at the Riverside Museum in New York, with the support of the International Fund for Concerned Photography, run by Cornell Capa.

1969 Don McCullin resigns. Charles Harbutt becomes president. He submits a book project to his colleagues Eve Arnold, Cornell Capa, Bruce Davidson, Elliott Erwitt, Burt Glinn, Philip Jones Griffiths, Danny Lyon, Constantine Manos, Don McCullin, Wayne Miller, Dennis Stock and Burk Uzzle in New York: *America in Crisis*.

1970 Sergio Larrain and George Rodger become contributors. Magnum Films is dissolved. Marc Riboud is the only photojournalist able to enter North Vietnam. His book *Face of North Vietnam* is published only in the US.

1971 Philip Jones Griffiths becomes a member.

1972 Leonard Freed becomes a member. Burt Glinn becomes president.

1973 Published by the MIT Press, Charles Harbutt's first book, *Travelog*, goes on to win the award for Best Photo

Book at the following year's Recontres d'Arles.

1974 Paul Fusco, Mark Godfrey, Josef Koudelka and Gilles Peress become members. US publication of *Son of Bitch*, the first in a series of books by Elliott Erwitt on one of his favourite subjects: dogs.

1975 Marc Riboud becomes president. Herbet List dies at the age of 72.

1976 Charles Harbutt becomes president again.

1977 Richard Kalvar, Guy Le Querrec and Mary Ellen Mark become members.

1978 Marilyn Silverston becomes a contributor. Burk Uzzle becomes president. W. Eugene Smith dies at the age of 60.

1979 Raymond Depardon and Alex Webb become members. Erich Lessing becomes a contributor. *This Is Magnum*, a major group exhibition, is held in Tokyo and Osaka. Death of Philippe Halsman, at the age of 73, and of Kryn Taconis, at the age of 61.

1980 Susan Meiselas becomes a member. Wayne Miller and Marc Riboud become contributors. Danny Lyon resigns. Philip Jones Griffiths becomes president.

1981 Charles Harbutt, Mark Godfrey and Mary Ellen Mark resign. The group exhibition *Paris Magnum: Photographies 1935–1981* is held at the Musée du Luxembourg in Paris and the ICP in New York. In Washington DC, Sebastião Salgado photographs a crazed man named John Hinckley who fires six shots at President Ronald Reagan outside the Hilton Hotel.

1982 Eugene Richards becomes a member. Burk Uzzle resigns. Mary Ellen Mark publishes her book on prostitution in Bombay, *Falkland Road*. Magnum Photos opens its first gallery, in Paris. One of the first exhibitions, *Terre de guerre*, is devoted to the Middle East.

1983 Martine Franck and Chris Steele-Perkins become members. Cornell Capa becomes a contributor. Philip Jones Griffiths photographs the US invasion of Grenada.

1984 Sebastião Salgado becomes a member. On behalf of Médecins Sans Frontières and *Libération*, he goes to the Sahel region of Africa where two and a half million people are fleeing from famine.

1985 Abbas becomes a member. Erich Hartmann becomes president.

1986 Jean Gaumy, Harry Gruyaert and Peter Marlow become members. Gilles Peress becomes president. Death of Ernst Haas at the age of 65. Magnum opens a London office.

1987 Burt Glinn becomes president once again. The Magnum gallery in Paris closes.

1988 Michael Nichols and Eli Reed become members. First major group exhibition at the Rencontres d'Arles festival with *Magnum en Chine*. Death of Brian Brake at the age of 61.

1989 Thomas Hoepker, Hiroji Kubota, James Nachtwey and Ferdinando Scianna become members. Gilles Peress becomes president again. Guy Le Querrec, Bruno Barbey, René Burri, Gilles Peress and Raymond Depardon cover the fall of the Berlin Wall. The exhibitions *Magnum, 50 ans de photographies* and *In Our Time: The World as Seen by Magnum Photographers*, curated by Robert Delpire, are simultaneously launched at the CNP in Paris and the ICP in New York, together with books of the same titles. In total, this group project is shown at twenty-eight international museums.

1990 Stuart Franklin and Patrick Zachmann become members. Peter Marlow becomes president. Magnum opens a Tokyo office. The process of digitizing the Magnum archives begins. The exhibition *À l'est de Magnum* opens at the Rencontres d'Arles. In partnership with the Fondation Soros, it goes on to

be shown in countries including Armenia, Georgia, Uzbekistan, Kyrgyzstan, Mongolia and Azerbaijan.

1991 Abbas, Bruno Barbey and Steve McCurry cover the Gulf War, the most heavily covered war since Vietnam. *Time*, *Newsweek*, *National Geographic* and *Life* publish their images exclusively.

1992 Bruce Gilden publishes *Facing New York*, which brings together photographs taken between 1984 and 1992 of anonymous people in the city.

1993 Steve McCurry and Larry Towell become members. After seven years of work, Sebastião Salgado publishes *Workers*, which is translated into nine languages and features in some sixty exhibitions.

1994 Carl de Keyzer, Nikos Economopoulos, Martin Parr and Gueorgui Pinkhassov become members. Erich Hartmann becomes a contributor. Sebastião Salgado resigns. The exhibition *Magnum Cinema*, accompanied by a book, is held for the Mois de la Photo in Paris and tours fifty-five locations worldwide. An auction of Magnum photographs is held at Christie's in London. Eugene Richards publishes the acclaimed *Cocaine True, Cocaine Blue*, about the devastating effects of drug use in Brooklyn and North Philadelphia.

1995 Eugene Richards resigns. Chris Steele-Perkins becomes president. George Rodger dies at the age of 87.

1996 Michael Nichols resigns.

1997 David Alan Harvey, John Vink and Donovan Wylie become members.

1998 Luc Delahaye becomes a member. Abbas becomes president. Publication of *1968 – Magnum à travers le monde*, a collective work that commemorates the 30th anniversary of the popular uprisings that took place in that year. Another group work, *Israel: Fifty Years as Seen by Magnum Photographers*, is published on the 50th anniversary of the founding of the state of Israel.

1999 Gilles Peress becomes a contributor. The Centro Reina Sofía in Madrid pays tribute to Robert Capa and his images of the Spanish Civil War in the exhibition *Heart of Spain*.

2000 The *Magnum Degrees* book and exhibition trace recent major events of the 20th century, following the fall of the Berlin Wall. Almost simultaneously, exhibitions at the Barbican in London and Bibliothèque Nationale in Paris bring together 56 photographers and 420 prints.

2001 Chien-Chi Chang, Alex Majoli and Lise Sarfati become members. James Nachtwey resigns. Peter Marlow becomes president. Publication of *New York September 11 by Magnum Photographers*, two months after the tragedy in New York. Steve McCurry, Susan Meiselas, Larry Towell, Gilles Peress, Thomas Hoepker, Alex Webb, Paul Fusco, Eli Reed, David Alan Harvey and Bruce Gilden are all in the city on the day of the attacks. The book is accompanied by an exhibition at the New York Historical Society Museum. Part of the profits from the book are donated to the New York Times 9/11 Neediest Fund, to help the families of the victims.

2002 Bruce Gilden becomes a member. Inge Morath dies at the age of 79.

2003 Thomas Hoepker becomes president.

2004 Thomas Dworzak becomes a member. Henri Cartier-Bresson dies on 3 August, just before his 96th birthday. *Magnum Stories*, a group work, is published, edited by Chris Boot, former director of Magnum New York. On the 50th anniversary of the deaths of Werner Bischof and Robert Capa, the New York office organizes the citywide *Magnum In May* festival. Twelve photographers – Lise Sarfati, Patrick Zachmann, Jim Goldberg, Carl de Keyzer, Constantine Manos, Nikos Economopoulos, Alex Webb, Bruce Gilden, Richard Kalvar,

Josef Koudelka, Miguel Rio Branco, Mark Power – take part in the 'Periplus' project, capturing a vision of contemporary Greece on the occasion of the Athens Olympics. The exhibition *Robert Capa connu et inconnu* takes place at the Bibliothèque Nationale de France. Magnum Photos launches the annual review *M*, with the goal of questioning the world and its documentary representation. Paolo Pellegrin, Geert Van Kesteren, Stuart Franklin and John Vink cover the aftermath of the Indonesia tsunami.

2005 Paolo Pellegrin becomes a member. Luc Delahaye resigns. Magnum produces and publishes *Fashion Magazine*, devoted to fashion and entirely created by Martin Parr. Works by Christopher Anderson, Antoine D'Agata, Thomas Dworzak, Alex Majoli, Paolo Pellegrin and Ilkka Uimonen are featured in the exhibition *Off Broadway*, first shown in New York and then in Arles and Milan. Central to this show are works on Iraq, the former Yugoslavia, the Israel-Palestinian conflict and Chechnya. Hurricane Katrina devastates New Orleans. Christopher Anderson, Thomas Dworzak and Larry Towell photograph the aftermath of the tragedy. The Centre Pompidou in Paris hosts a Magnum group show for the first time. The *Euro*

Visions project involves ten Magnum photographers visiting ten countries that joined the European Union in May 2004: Martine Franck (Czech Republic), Mark Power (Poland), Lise Sarfati (Lithuania), Patrick Zachmann (Hungary), Peter Marlow (Cyprus), Chris Steele-Perkins (Slovakia), Alex Majoli (Latvia), Donovan Wylie (Estonia), Martin Parr (Slovenia) and Carl de Keyzer (Malta). The project is extended in 2007 by Bruno Barbey (Bulgaria) and Paolo Pellegrin (Romania).

2006 Jim Goldberg becomes a member. Stuart Franklin becomes president. Henri Cartier-Bresson's *Scrapbook*, originally dating from 1946, is published and accompanied by an exhibition at the Fondation HCB. Raymond Depardon is guest artistic director at the Rencontres d'Arles. Leonard Freed dies at the age of 77. A new Magnum website is launched, featuring 'Magnum in Motion', a series of multimedia photo essays, and blogs by some of the photographers.

2007 Magnum celebrates its 60th anniversary. Exhibitions are held all over the US and across Europe – Turkey, Germany, Spain, Belgium – as well as the agency being linked with the Rencontres d'Arles festival and the 60th anniversary of the Cannes Film Festival.

BIBLIOGRAPHY

Magnum's Global Photo Exhibition, Tokyo: The Mainichi Newspapers/Camera Mainichi, 1960

Let Us Begin: The First 100 Days of the Kennedy Administration, Richard L. Grossman (ed.), New York: Simon & Schuster, 1961

Creative America, New York: Ridge Press for the National Cultural Center, 1961

J'Aime le Cinéma, text by Franck Jotterand, Lausanne: Éditions Rencontre, 1961

Fotos van Magnum, Amsterdam: Stedelijk Museum/Magnum Photos, 1963

Peace on Earth, text by Pope John XXIII, photographs by Magnum, New York: Ridge Press/Golden Press, 1964

Messenger of Peace, New York: Doubleday, 1965

America in Crisis, photographs selected by Charles Harbutt and Lee Jones, text by Mitchel Levitas, New York: Ridge Press/Holt, Rinehart and Winston, 1969

This Is Magnum, Tokyo: Pacific Press/Magnum, 1979

Magnum Photos, introduction by Hugo Loetscher, Saint-Ursanne, Switzerland, 1980

Paris, 1935–1981, introduction by Inge Morath, text by Irwin Shaw, New York: Aperture, 1981

Terre de Guerre, René Burri and Bruno Barbey (eds), text by Charles Henri-Favrod, Paris: Magnum Photos, 1982

After the War Was Over, introduction by Mary Blume, London: Thames & Hudson, 1985; also French and German editions

Magnum Concert, introduction by Roger Marcel Mayou, Fribourg: Triennale Internationale de la Photographie au Musée d'Art et d'Histoire, 1985

The Fifties: Photographs of America, introduction by John Chancellor, New York: Pantheon Books, 1985

Bons Baisers, Collection Cahier d'Images, Paris: Contrejour, 1987

Israel: The First Forty Years, William Frankel (ed.), introduction by Abba Eban, London: Thames & Hudson, 1987

China: A Photohistory, 1937–1987, London: Thames & Hudson, 1988

Terre Promise: *Quarante Ans d'Histoire en Israël*, Paris: Nathan Image, 1988

In Our Time, William Manchester (ed.), text by Jean Lacouture, New York: W. W. Norton & Co., 1989

Magnum: 50 Ans de Photographies, text by William Manchester, Jean Lacouture and Fred Ritchin, Paris: Éditions de La Martinière, 1989

À l'Est de Magnum, 1945–1990, René Burri, Agnès Sire and François Hébel (eds), Paris: Arthaud, 1990

Music, Michael Rand and Ian Denning (eds), London: André Deutsch, 1990

Ritual, Michael Rand and Ian Denning (eds), London: André Deutsch, 1990

Heroes and Anti-Heroes, introduction by John Updike, New York: Random House, 1992

Magnum Cinéma, Agnès Sire, Alain Bergala and François Hébel (eds), text by Alain Bergala, Paris: Cahiers du Cinéma/Paris Audiovisuel, 1994

Americani, introduction by Denis Curti and Paola Bergna, text by Fernando Pivano, Milan: Leonardo Arte, 1996

Guerras Fratricidas, Agnès Sire and Martha Gili (eds), texts by Régis Debray, Javier Tusell and José Maria Mendiluce, Barcelona: Fundació La Caixa, 1996

Magnum Landscape, text by Ian Jeffrey, London: Phaidon, 1996

Magnum: Fifty Years at the Frontline of History, text by Russell Miller, New York: Grove Press, 1997

Magnum Photos, Photo Poche, Paris: Nathan, 1997

1968: Magnum dans le Monde, texts by Eric Hobsbawm and Marc Weizmann, Paris: Hazan, 1998

Israel, Fifty Years, New York: Aperture, 1998

Murs, Sommeil, Combattre, Arbres, Stars, Couples, Déserts, Naître, La Nuit, Écrivains (series), Jean-Claude Dubost, Marie-Christine Biebuyck and Agnès Sire (eds), Paris: Finest SA/Éditions Pierre Terrail, 1998

Magna Brava: Magnum's Women Photographers (Eve Arnold, Martine Franck, Susan Meiselas, Inge Morath and Marilyn Silverstone), text by Sara Stevenson, Munich: Prestel, 1999

The Misfits, London: Phaidon, 1999

GMT 2000, A Portrait of Britain at the Millennium, HarperCollins, London, 2000

Magnum Degrees, introduction by Michael Ignatieff, London: Phaidon, 2000

New York September 11 by Magnum Photographers, introduction by David Halberstam, New York: Powerhouse Books, 2001

Arms Against Fury, Magnum Photographers in Afghanistan, texts by Mohammad Fahim Dashty, Douglas Brinkley, Lesley Blanch, John Lee Anderson and Robert Dannin, New York: Powerhouse Books; London: Thames & Hudson, 2002

Magnum Football, London: Phaidon, 2002

La Bible de Jérusalem, Paris: Éditions de La Martinière, 2003

Magnum Photos Vu par Sylviane de Decker Heftler: Paris Photo, 2002–2003, Trézélan, France: Filigranes, 2003

New Yorkers as Seen by Magnum Photographers, New York: Powerhouse Books, 2003

The Eye of War, London: Weidenfeld & Nicolson, 2003

Magnum M1: Rencontres Improbables, Göttingen: Steidl/Magnum Photos, 2004

Magnum Photos Vu par Michael G. Wilson: Paris Photo, 2004, Trézélan, France: Filigranes, 2004

Magnum Stories, London: Phaidon, 2004

Muhammad Ali, New York: Harry N. Abrams, 2004

Periplus: Twelve Magnum Photographers in Contemporary Greece, text by Sylviane de Decker-Heftler, Paris: Atalante, 2004

EuroVisions: The New Europeans by Ten Magnum Photographers, text by Diane Dufour and Quentin Bajac, Göttingen: Steidl; Paris: Magnum Photos/Centre Georges-Pompidou, 2005

Magnum Histories, Chris Boot (ed.), London: Phaidon, 2005

Magnum Ireland, Brigitte Lardinois and Val Williams (eds), introduction by John Banville, texts by Anthony Cronin, Nuala O'Faolain, Eamonn McCann, Fintan O'Toole, Colm Tóibín and Anne Enright, London: Thames & Hudson, 2005

Magnum M2: Répétitions, Göttingen: Steidl/Magnum Photos, 2005

Magnum Sees Piemonte, texts by Giorgetto Giugiaro, Erik Kessel and Diane Dufour, Regione Piemonte, 2005

Venedig, photographs by Mark Power, Gueorgui Pinkhassov, Martin Parr, Paolo Pellegrin and Robert Voit, Hamburg: Mare, 2005

L'Image d'Après: Le Cinéma dans l'Imaginaire de la Photographie, texts by Serge Toubiana, Diane Dufour, Alain Bergala, Olivier Assayas and Matthieu Orléan, Göttingen: Steidl; Paris: Magnum/La Cinémathèque Française, 2007

Madrid Imigrante: Seis Visiones Fotográficas sobre Imigración en la Comunidad de Madrid, texts by Joaquim Arango, Chema Conesa, Eduardo Punset and Diana Saldana, Madrid: Comunidad de Madrid, 2007

Tokyo Seen by Magnum Photographers, text by Hiromi Nakamura, Tokyo: Magnum Photos, 2007

Turkey by Magnum, introduction by Oya Eczacibasi, texts by Diane Dufour and Engin Ozendes, Istanbul: Istanbul Museum of Modern Art, 2007

Magnum Magnum, Brigitte Lardinois (ed.), London and New York: Thames & Hudson, 2007